About the author

Paul Riley studied art at Kingston College of Art.
'60 he was the youngest painter to have exhibited his
work at the Royal Academy.
His first one-man exhibition was held in 1961.
e has subsequently had exhibitions at many private
galleries in England as well as shows in Belgium,
Germany, Kuwait and Australia. He is a regular contributor
to *The Artist* magazine.
Paul established the Coombe Farm Studios art centre
Dittisham, Devon in 1982, where he continues to teach
both watercolour and oil painting as well as tutoring
groups in Europe and the Far East.

www.rileyarts.com

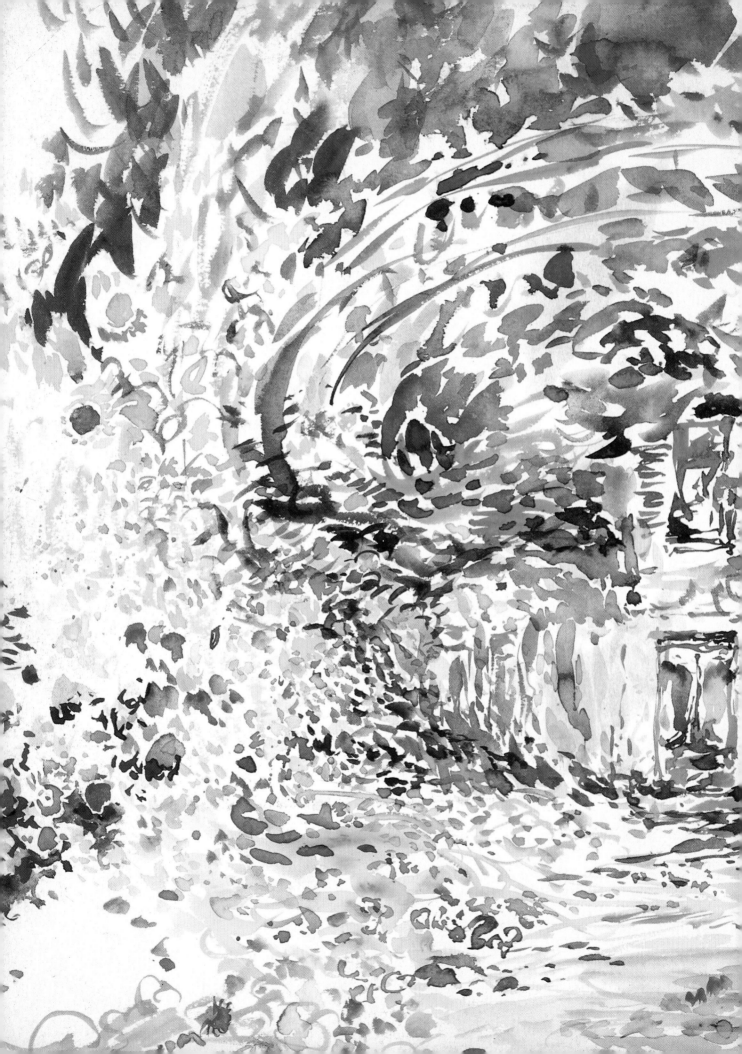

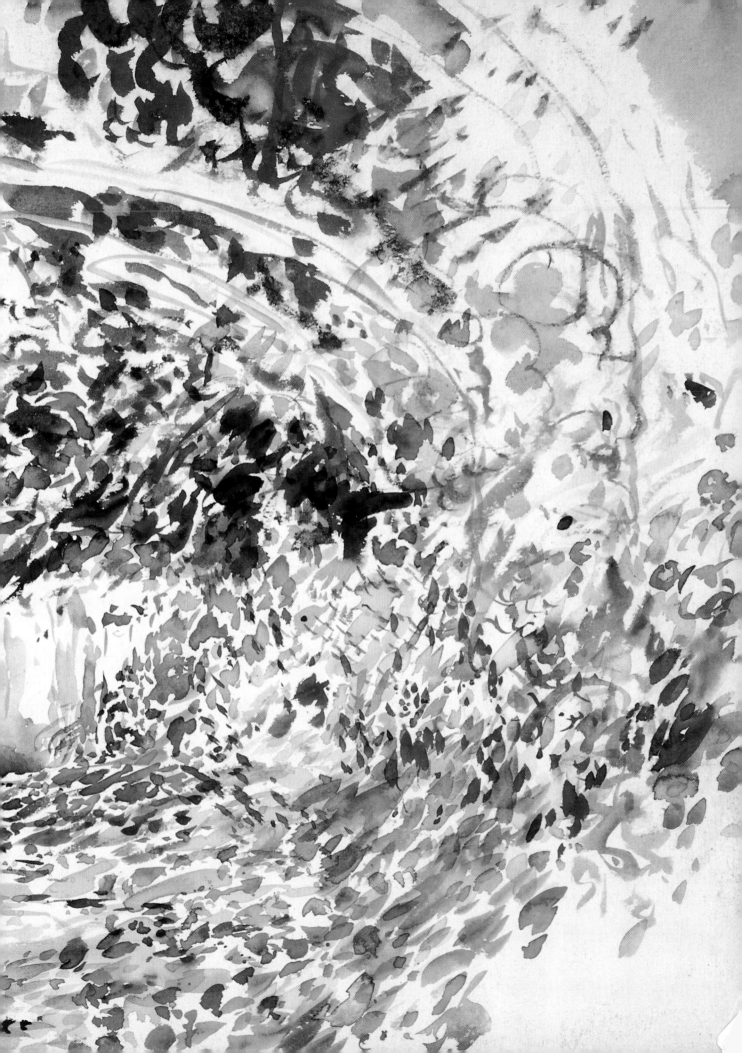

DAVID PORTEOUS ART AND CRAFT BOOKS

Flower Painting Paul Riley
Watercolour Landscapes Paul Riley
The Dough Book Brenda Porteous
Wooden Toys Ingvar Nielson
Papier Mâché Lone Halse
Pressed Flowers Pamela Le Bailly
Cats: A Cross Stitch Alphabet Julie Hasler
Gift Boxes Claus Zimba Dalby
Decorative Boxes Susanne Kløjgård
Paper Craft Dette Kim
Fairytale Doughcraft Anne Skødt
Dolls' Clothes Mette Jørgensen
**Create Greeting Cards with
Glass Painting Techniques** Joan Dale

PAUL RILEY'S
WATERCOLOUR
WORKSHOP

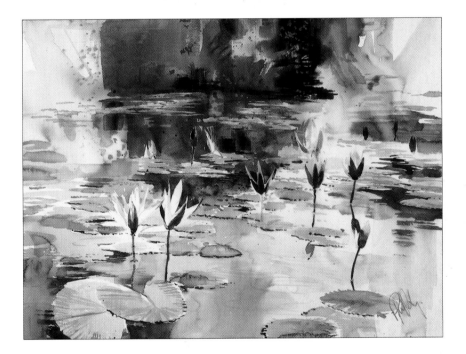

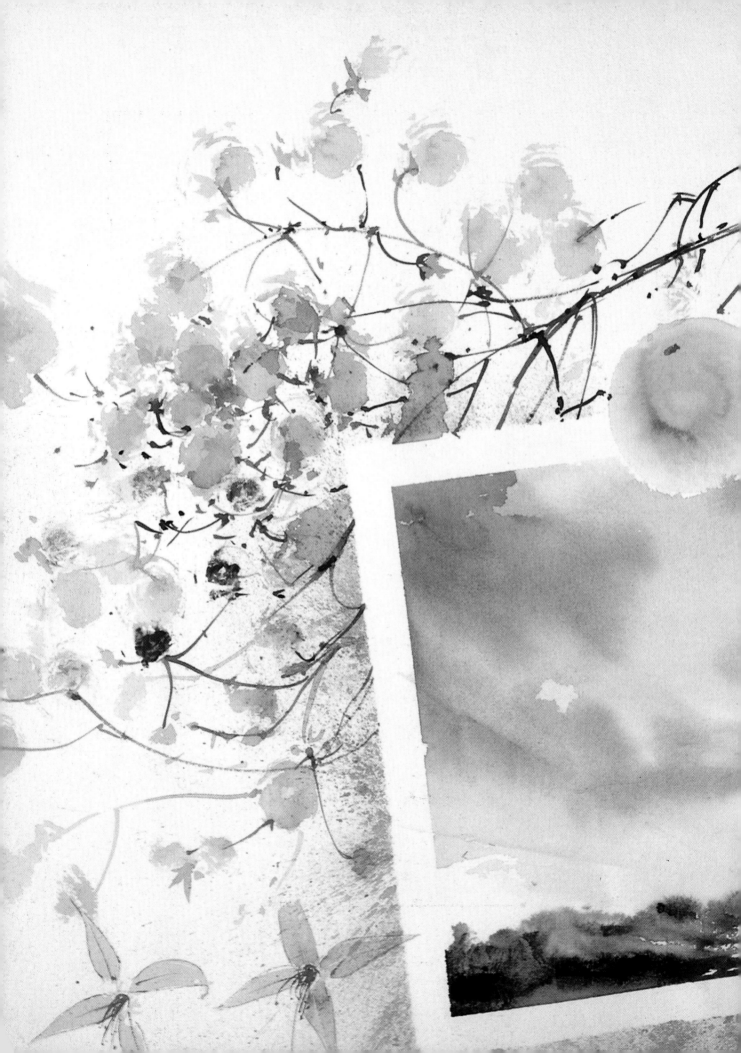

PAUL RILEY'S
WATERCOLOUR
WORKSHOP

DAVID PORTEOUS
Parkwest, New York

Ad Mater et Pater
in gratia

A CIP catalogue record of this book
is available from the British Library

Library of Congress Control Number: 2001090477

Hardback ISBN 1 870586 44 1
Paperback ISBN 1 870586 45 X

First published in the UK in 2001 by
David Porteous Editions
PO Box 5, Chudleigh
Newton Abbot
Devon TQ13 0YZ

www.davidporteous.com

First published in the United States in 2001 by
Parkwest Publications
451 Communipaw Avenue
Jersey City
N.J. 07304

www.parkwestpubs.com

©2001 Paul Riley

Printed in Spain.

CONTENTS

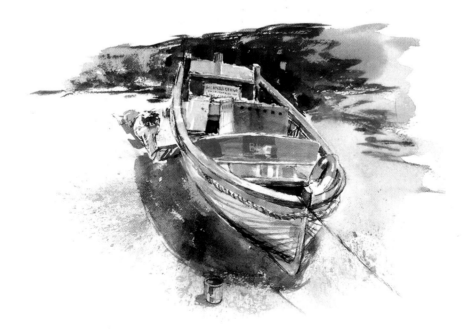

INTRODUCTION

I HAVE BEEN PAINTING IN WATERCOLOUR for a very long time now. Not so long, however, that I cannot remember my early forays as a young child using proper paints for the first time!

These belonged to my father, an accomplished painter in his own right. The paints were little tubes of delight, like sweets in fancy wrappers with exotic names like cerulean blue, Hooker's green, aureolin and ultramarine. Names that rolled off the tongue invoking images of the old masters that had used them – not like the powdery red, yellow and blue of school paints.

At school we were asked once to produce little five-inch square historical illustrations to be projected on an antiquated epidiascope. These small paintings were my first introduction to the complexities of the sometimes infuriating medium that watercolour can be. I recall I had a much-loved No 2 sable that I would clean assiduously, never leaving it in my water pot and risking a severe rap of the knuckles. With this brush I was able to paint incredibly fine detail until age affected my eyesight. Sometimes I added too much detail, a disease that most beginners catch, but a stage that nevertheless we all go through. Over the years I have added more and more techniques to my repertoire, which I hope to share with you in this book.

If you are a beginner, my aim is to introduce you to this magical medium by first demystifying some of the terminology, then by introducing the basics, and lastly via the intermediate to the advanced stages, thus enabling you to grapple with the medium. If, however, you have been painting for some time, I will give you an insight into my working methods, which I hope will stimulate new ideas and directions. This is a tall order that I am sure will tax my abilities, but it is a challenge I relish!

I shall cover several subject areas including Still Life, Life painting and Portraiture, Landscape, Buildings and Interiors. This workshop is no sweatshop. It is a place where all kinds of things can happen – incidents and accidents, tears and joy. Let this book take you on a voyage of discovery where, though you may not end up as masters of the craft, you will certainly develop a much greater understanding, which in turn will enable you to read in depth the efforts of others.

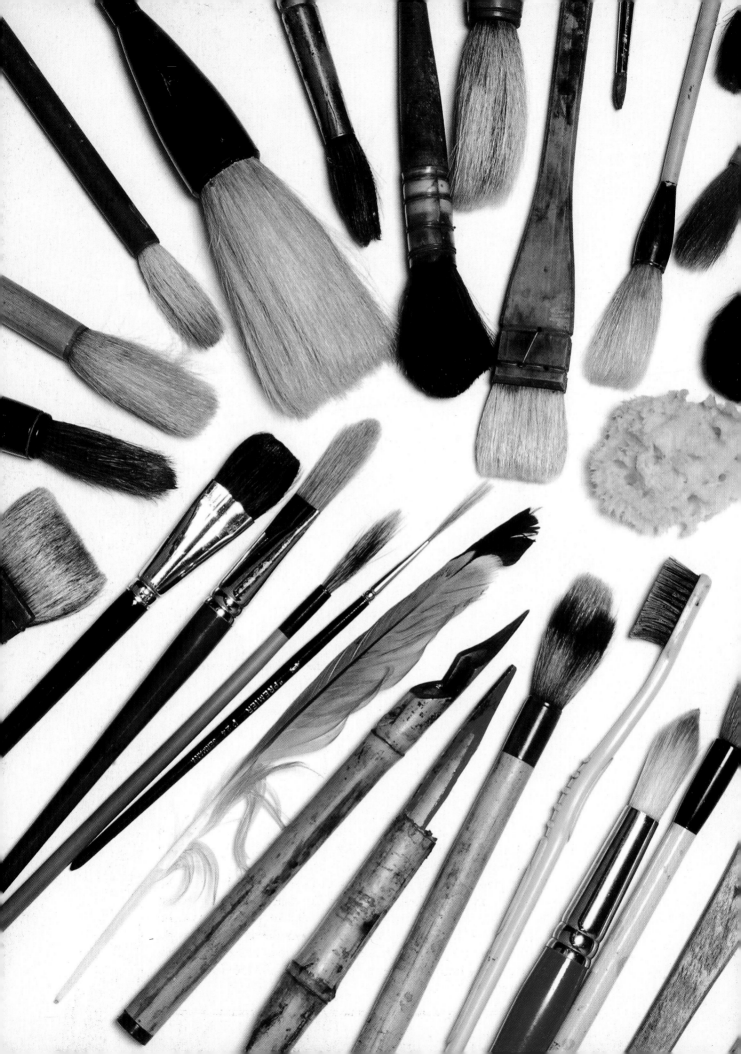

CHAPTER 1

TOOLS

Selection of tools and materials should not be an arbitrary decision. Fitness for their intended purpose means that only those that do the job properly will do, and quality is paramount. I will show you that, with careful selection, you can avoid the pitfalls that often cause despair. In time you will learn to use the brush in a more sensitive way that allows it to literally dance over the paper. Choosing the right paper means that it will take the paint from the brush in a clean, sparkling way and further enhance your work. Whether you are painting the delicate change of hue in a portrait, or the gnarled branch of a tree, there is a specific tool for the job. Let us see how to select it.

THE WAY OF THE BRUSH

In my schooldays we were taught to use a pencil to carefully draw round a specific shape then neatly fill it in with colour. We were told that if we did not go over the edge of our drawing there was the faint possibility that we might turn into artists! I was not very good at this and it was several years before I eventually dispensed with the pencil and worked exclusively with the brush. Ever since then I have been a brush enthusiast.

The trouble with drawing a line around an object is that, to the viewer's eye, it has a tendency to flatten that object. The reason is that the edge of the object will have the same tonal value and so loose all sense of depth. Hard edges are all very well if your painting is simply about patterns of colour but if you want to create the illusion of more depth you need both hard and soft edges. These can only be achieved with a brush. In addition, watercolour is such a versatile, sensitive medium that it responds particularly well to brush manipulation. This can be readily seen in Oriental painting where the brushes are designed to depict whole forms from the smallest, such as birds' feet, to large branches and even mountains.

All brushwork requires skill in manipulation. Most beginners tend to hold the brush in a vice-like grip

Small Stream
The tools used on this image range from small brushes to folded pieces of card. The details in the stones and grass were painted with a small round sable, and larger strokes with a soft round squirrel hair. Masking fluid, applied with folded card, was used for the grass textures and the spray in the water. Oriental brushes and a one stroke sable were used to apply vigorous brushwork to the background. This was augmented by scraping out the various white lines with a penknife. Rock textures were made by lightly brushing with a wax candle. Splattering and small dots of wild flowers were put in by flicking with a toothbrush.

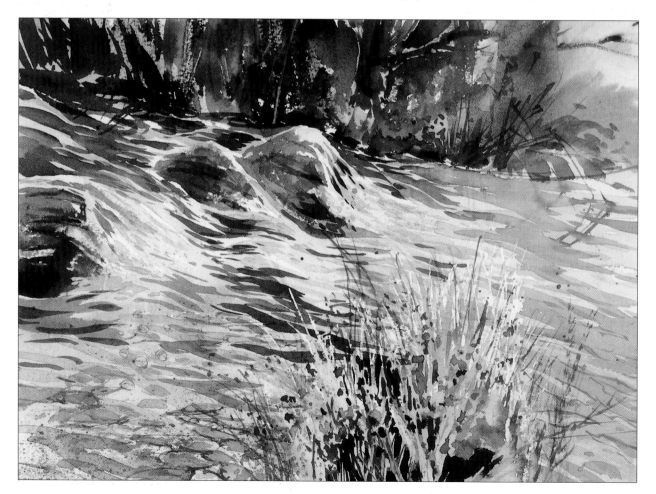

Small Round Sable

Small round sable brushes range in size from 000 for miniaturists to approximately size 6. These brushes are probably the most essential in the watercolourist's kit. They are used for all detail work and for initial drawing-in stages. Their springy sable hair enables the watercolourist to work with great dexterity.

Large Round Sable

The joy of good quality sable brushes is that they can form an extremely fine tip. They also have a generous body which will hold copious quantities of paint that can be directed exactly where the artist wishes. When using these brushes you can work from tip to body in order to produce a stroke of varied width. This is useful when depicting water, for example. The large round sable is also ideal where large washes and detailed control are required.

Rigger

So called because this brush was initially invented for marine painters to paint rigging on sailing ships. It has a versatile nature that can be used in many ways, for example painting fine grasses, branches of trees, or anywhere that a fine line is required. The technique of handling is to trail the tip across the paper which then gives considerable control over the direction of the line.

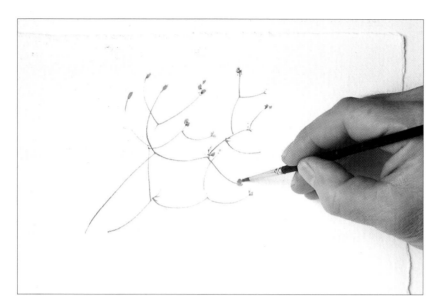

Spotter

The spotter is another brush designed for miniaturists to use where paint is applied in very small dots. It can, therefore, be used by watercolour painters to achieve the same kind of effect, or for anything else that requires small touches of paint. I use it for flower painting whenever there are small markings on petals. It is also ideal for portraits when working in and around the eyes. It has a very short, stubby tip ideally suited to this kind of work.

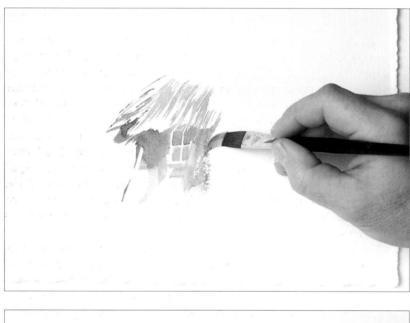

One Stroke Sable

The one stroke sable has a flat ferule, which is the metal part of the brush, and a cut-off chisel-like edge to the bristles. In a good quality sable this comes to an extremely fine line. The brush can be manipulated so that fine lines, together with very broad strokes, can be achieved. By turning the brush between the fingertips it is possible to produce lines of varying thickness. This is ideally suited for the depiction of water.

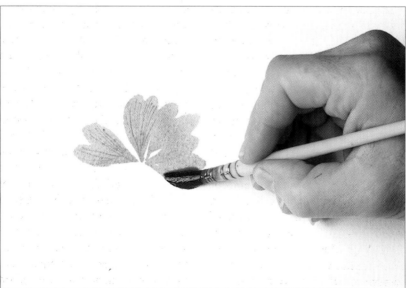

Large Round Squirrel Hair

Squirrel brushes have very soft hair which enables the painter to 'print' a mark and to produce soft, fluid shapes. It is ideally suited for petals and leaves. When handling this brush you need to work from tip to body to vary the stroke. The soft hair takes kindly to two-colour work where the body of the brush is dipped in one colour and the tip in another to produce a varied brush stroke.

Small Squirrel Hair

Here I have first trailed a sable line for the stalks. The leaves are then painted with the aid of a soft squirrel hair brush. The brush is pressed down lightly in one stroke to form the leaf shapes.

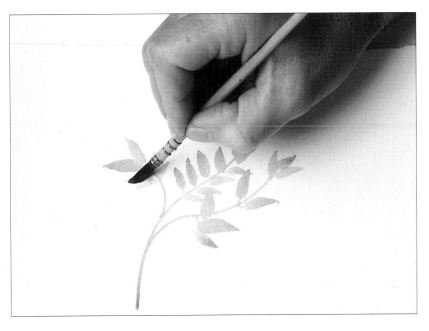

that results in a cramped style of work. It is important that the brush is held in such a manner as to allow maximum flexibility in the stroke. The main problem encountered is the control of the very tip of the brush. The tendency therefore is to rest the hand on the paper. This has a couple of drawbacks. Firstly the natural oils in your skin may impregnate the sensitive paper thereby causing what we call a resist, which leaves pale patches in any subsequent painting. Secondly there is the likelihood of the hand picking up paint and either smudging the surface, or even worse putting it where it is not wanted. The method I use to overcome this is to hold the brush in a relaxed manner by the ferrule and use my little fingernail to distance the brush from the surface of the paper. I even grow this nail a little longer than the rest in order to accomplish this manoeuvre! If you are seated when working the hand needs to be bent at the wrist to be kept clear of the paper. My preferred method is to work standing up. I keep my whole arm loose, which ensures complete flexibility of hand movement.

When using the brush I always like to bear in mind that the absorbency of the paper surface should take the paint from the brush, rather than use the brush to 'mash' the paint onto the paper. This approach ensures you are aware of the sensitivity of the brush. Keeping a relaxed grip on the brush enables you to manipulate the tip and body to produce varied strokes. Building up the strokes helps you to define forms that do not require a pencil to delineate them.

The most versatile, and the most often used brush in the watercolourist's kit is the sable. The finest of these is the Kolinsky (Siberian mink). The manufacturing and setting of a sable brush is an art form in itself and I take my hat off to the people who make them. Modern artificial hair cannot hold a candle to a well-made sable. Artificial fibre is parallel sided, which means that when the brush is made there are little or no interstices between the bristles to hold the watercolour, whereas the sable hair is curved and tapers from root to an infinitesimally fine tip. When the hairs are set the typical form of the brush can hold a good amount of colour which is then conveyed via capillary attraction exactly where you want it - to the tip.

Sables come in various sizes and shapes, all of which have their appropriate use depending on both the style and type of painting on which you are engaged. The parts of the brush that alter their shape, and hence their name, are the ferrule and the tip. The ferrule is the metal, or in some cases, quill sleeve that grips the hair. If the ferrule is circular in shape the brush is a 'round', if flattened it is described as a 'flat'.

Rounds come in various types, the smallest being a 'spotter', so described because its function is to produce small spots of colour. This is most often used by miniaturists and botanical artists who sometimes work by building up small dots and touches of colour which appear to merge when seen from a distance. The next type up is the round pointed-tip with a longer body of hair. This brush is often called a 'pencil' and is used as such for delineating, and detailed work in the smaller sizes. The larger sizes are used for detail and for laying large areas of colour wash.

When the ferrule is flattened it produces two types of brush, a 'chisel' or 'one stroke', which as the name implies has a square cut tip which when wet and viewed on

Fuschia

In this painting we see a full use of a range of brushes. No preliminary drawing was done and all the strokes were made with different brush shapes. The main stalks were put in using a larger sable and the colour was dotted in whilst the stems were wet. Fine lines were made with the rigger, and fuller strokes with a combination of oriental brushes and a soft squirrel hair brush. Crisp, narrower strokes were executed using a sable and traceur. For overpainting, the one stroke was used to indicate leaf veins. The small dots for the stamens were put in with the spotter. In this way a certain spontaneity is achieved wich avoids the 'tired' look that can sometimes result from labourious drawing and filling in.

end, will have an edge like a razor blade. If, however, the hairs are brought to a pointed tip it is called a 'filbert'. The one stroke is ideal for ribbon-like strokes for bricks, windows, grasses, and long leaves – anywhere you want to execute an italic-like stroke. The filbert, whose tip may be rounded or pointed, is ideal for certain types of petals and for leaves.

The basic characteristic of the sable hair is its supple springy feel, making it easier to control precisely. However, there are occasions when certain elements of the painting require a softer, more luscious stroke. For this, squirrel hair is ideal. It holds large quantities of water and produces a quick spontaneous mark. For those of you who feel your work is a little cramped this will certainly feel quite liberating. Colour washes can also be laid down swiftly when working on wet areas of paper.

Although squirrel is not as robust as sable when new they have a delightfully fine tip that achieves sharp, crisp detail.

One of the most useful techniques that I employ constantly for leaves and petals is what I call 'printing'. If you fully load the brush, then lightly drain the tip to a fine point, you can lay the brush down on its side on the paper, press, and make a print of the shape of the brush. Depending on

Combination Oriental Brush

This brush is very similar to the traceur in so far as the hairs are of two types. The centre hairs are wolf hair and are considered the drawing tip. These are surrounded by a soft goat hair. As with the traceur, this brush enables you to both draw and produce full-bodied strokes. The added advantage is that it can be used to produce very dry ragged edges, which is especially useful for textures.

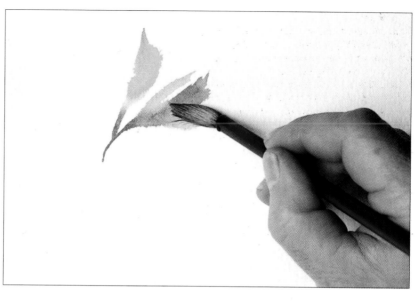

Traceur

This is a very versatile brush made in France by Isabey. It consists of a small core of fine sable which is surrounded by soft squirrel hair. This enables the painter to both draw and paint with the same brush. Its fine tip can produce delicate line work, whilst the soft sides can be pressed onto the paper surface to produce varied strokes. I find this particularly handy when painting leaves. It is also extremely useful in costume life painting for folds in fabric. It takes a little practise to get used to the thin tip but with perseverance it could be the best thing you have experienced.

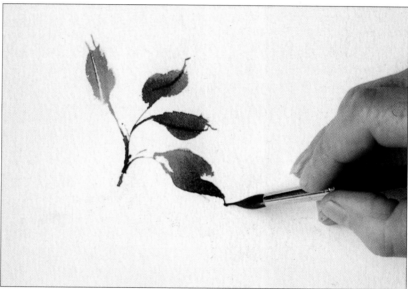

Hake

The particular characteristic of this brush is its broad, soft, goat hair which has a ragged edge. Ideally suited for broad, and even fine strokes when used on its edge, it can be manipulated in such a manner as to produce varied textures and marks. This brush is now popular amongst many watercolourists for landscapes. I also use it for background tones and shadows in still life painting. When dried out it can be used for dry brushwork. You can also paint various colours along its length to produce rainbow-like strokes.

the size of the brush you will produce different sized leaf or petal forms. You can also trail the brush and, by varying the pressure when working from tip to body and back again, execute water ripples, for example.

Squirrel hair brushes vary in shape in much the same way as sables. There are one strokes and filberts, including cut liners or angular liners which, though used mainly in the decoration of ceramics, are wonderfully versatile in the depiction of petals and even the folds in fabric. Also, being long-haired, when trailed they produce long lines which are ideal for painting branches, stems and so on. Another brush, unique to squirrel hair is the 'tinter', a stubby-ended brush which I use for stippling textures. It is good for undergrowth, textures on rocks – you name it!

Both sable and squirrel hair brushes are not cheap, and the larger they come the more expen-

sive they are. For large areas of wash a cheaper natural hair is equally acceptable. This is ox hair which again comes in various shapes and can be used like the others but it lacks the tip quality. I personally do not use artificial hair – ever! It has no sensitivity.

There is a whole world of other types of brushes that have their specialist uses. Some you may only use once in a blue moon, one or two others may be the answer to all your prayers and could only be prised from your grip with great force! These are the combination brushes and oriental types. By combination I mean that more than one hair type has been combined to make a brush with more possibe uses.

One such is the sable and squirrel mix. This has been based on a Japanese brush that uses the principles of having the central core of stiff hair, usually wolf hair, surrounded by a softer goat hair. The effect of this is that the central

Gaffer at Sea
Even when using only a small selection of brushes a painting can still be quite expressive. In this study I used both Western and Oriental style brushes. The small marks were put in with a small round sable, rigging with a rigger, and a spotter was used for small touches in the waves and in the boat. To obtain the sense of movement in the foreground waves I employed an Oriental brush with two colours on it. The vigorous foreground spray was dry brushworked using the same brush. The background sky was laid in very loosely with a large sable.

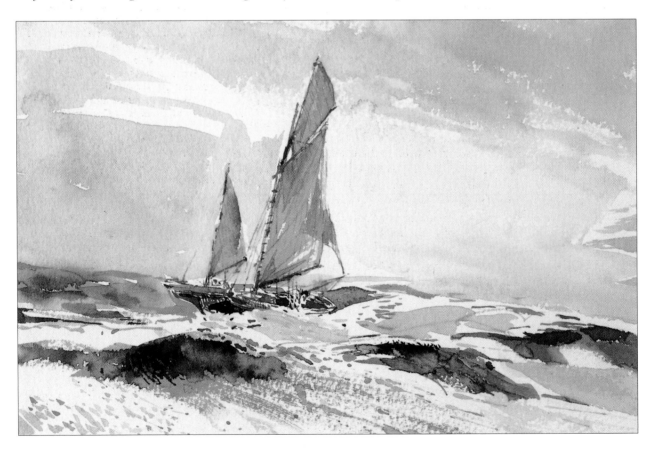

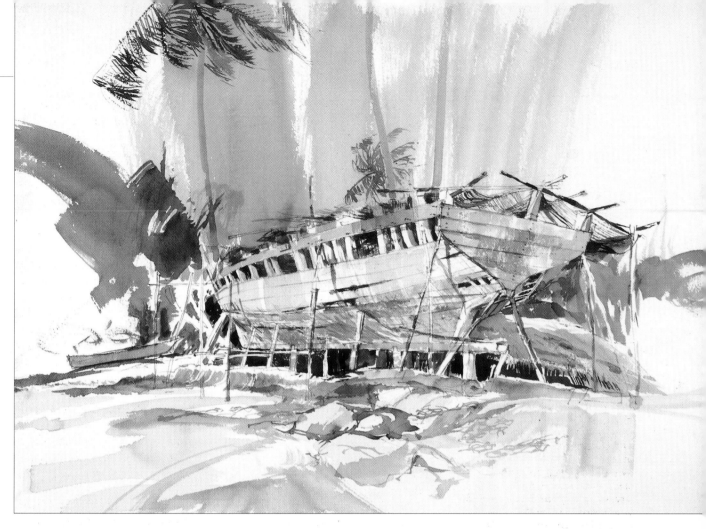

core acts as the drawing tip whilst the outer hair contains the colour for full-bodied strokes. This results in real versatility and enables you to draw and fill with great speed. I also use it for two-colour work, which you will see demonstrated. One company in France (Isabey) is, as far as I know, the only manufacturer of the sable-squirrel mix and long may they continue to do so. It is a brush you either love or hate. However, I know many students who say it has revolutionised their painting. The contrast between the tensile stable core and the soft squirrel sheath is extreme. You can put together delightfully spontaneous marks to depict anything from foliage to folds. I go from thick to thin in a trice but I do have to think about what I am doing. It will not do everything!

I have a very large collection of Oriental brushes acquired over the years. Some, I must confess, more for their handles than their function. They are mainly round with

the exception of the 'hake' which is a flat like our one stroke. The two main hair types are goat and wolf. Having said that, all kinds of hair have been used by the Oriental masters due to the fact that many of them made their own brushes. Many Western painters have problems using these brushes, mainly because they are soft and when used in the traditional western way (at an angle of forty-five degrees) they tend to bend over and stay that way. However, if you hold them vertically with the tip drained, you can execute extremely rapid and expressive strokes. The other thing I like about them is that the tip has a somewhat undisciplined nature that can result in some surprising marks that can be exploited in quite unique ways.

The hake is a particularly useful brush. It comes in a variety of widths and is made by the traditional Oriental method of stitching goat hair through a wooden

Boat building, Zanzibar

Although the building of this boat was in progress, the site had a wonderful air of delapidation. There were very many varied textures and brushstrokes in this study. To paint the crisp plank edging, gaps and holes I used the one stroke sable. In fact this brush was used almost entirely with the exception of the even broader strokes, for which I used the hake. The rocks in the foreground and much of the texture were painted with the traceur. I was able to both draw and place in the more 'lumpy' strokes in practically one go. Much of the texture was made with the Oriental brush using a sideways scraping stroke.

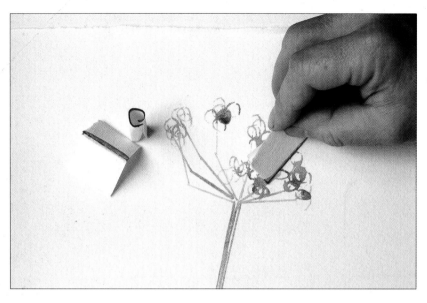

Painting with Paper

You do not always have to use a brush to paint with, and crisp straight lines can sometimes be best achieved using folded paper dipped in paint. I find this useful for depicting dried plants and woodwork. Not only can it be used for linework but by side scraping it is ideal for textures and, when rolled into small cylinders, can simulate the appearance of seed heads. The ideal paper for this is the very same watercolour paper you use for your painting.

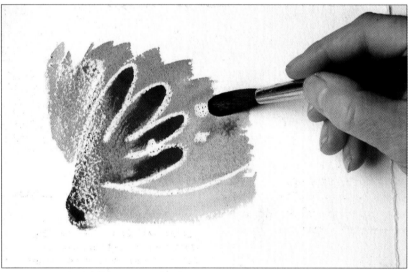

Resist Techniques

The two main forms of resist are art masking fluid and the wax candle. Art masking fluid comes in liquid form and can be painted or penned onto the paper. The wax candle can be used either on its side to produce flat resist areas, or sharpened and used as a crayon for linework. In fact coloured wax crayons can be used in a similar way. When removing the masking fluid my technique is to use a dried up ball of the masking fluid as an eraser. The wax can stay on the paper as it is non-perishable.

handle. It can be used on edge to give ragged lines or on the flat to provide broad swathes of colour. Again, you can twist the brush between your fingers to vary the width of stroke. Colour variation in the stroke can be engineered by using another brush to apply colour to the hake. This way you can paint rainbows!

As you can see from all the above the brush makers have invented a plethora of types to meet practically every need of the artist. However, the individual artist is constantly creative and will come up with new ways of doing things. I have all kinds of miscellaneous tools that solve the many

problems encountered when painting. Perhaps the most useful is the small natural sponge which I find invaluable in the latter stages of a painting. It is used mainly for softening edges, principally to create depth (the softer the edge of an object the further away it appears). I also use the sponge to apply soft veils of colour, sometimes at the outset of the painting by way of an underwash. This can set the mood of a painting.

Alternative tools can include rags, folded paper, candles, feathers, toothbrushes, sticks, pens or whatever comes to hand. Almost anything that will hold paint can be pressed into service. However, I do

warn people that some of the marks produced by these methods can appear contrived if used excessively. So, as with many things in life, moderation is the word! Many of the tools mentioned above are mainly used for obtaining textures, which you will see demonstrated later. Some, when you play with them, can produce unexpected results, which will add some spontaneity to your work. Painting with feathers is an example. Try doing a portrait – you will be surprised by the effect. Another tool I use is masking tape, especially when I want a straight-line edge between washes. This is very useful for horizons at sea. You can always

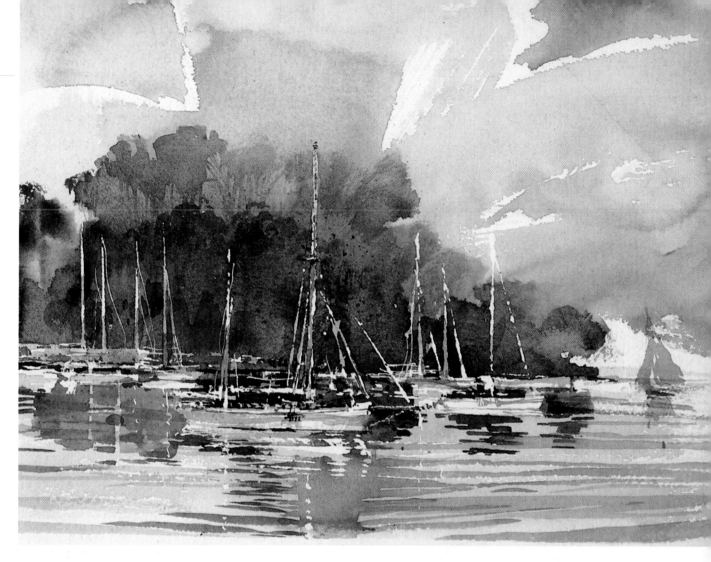

soften the edges with the sponge later if they are too hard.

Splattering with a toothbrush will give a wide variety of textures. Be sure to mask with newspaper any areas where you do not want the splattering. A wax candle is especially effective when rubbed over a NOT surface of rough paper. The raised texture will pick up wax and then act as a resist to any subsequent wash – ideal for bricks, bark on trees and spume on water.

On the question of tools I leave you with a quote from the Buddhist Hsieh Ho concerning the six enigmatic principles (of painting) written in 520 AD.

1. Animation through spirit consonance
2. Structural method in the use of the brush.
3. Fidelity to the object in portraying forms.
4. Conformity to kind in applying colours.
5. Proper planning.
6. Transmission of the experience of the past in making copies.

PAPER

Having selected the right tools you need the appropriate paper. The main requirement for a good watercolour paper is that it is robust enough to take a thorough soaking without disintegration. Good quality papers are made using the finest ingredients of which there are two types – wood pulp and cotton rag. Cotton rag paper is the very best. Wood pulp is high in cellulose and will harden in time and ultimately become brittle. In terms of absorbency it is harder than the cotton rag and is therefore more forgiving for the beginner to use – for example it is easier to erase on a harder paper. Cotton rag is archival which means

Riverboats
I have used various resist techniques in this small study to create an impressionistic view of the boats. Folded card dipped into masking fluid has been imprinted on the paper. This was used for the masts and rigging and for simple wedge-like shapes for distant boats. This effect works best when the painting has a fluid, free style. Care must be taken to ensure that the paintwork is dry before removing the fluid. One word of caution – do not be tempted to use a hairdryer or any other fast drying method to cure the fluid as this can result in burning the fluid into the paper, thereby making it very difficult to subsequently remove.

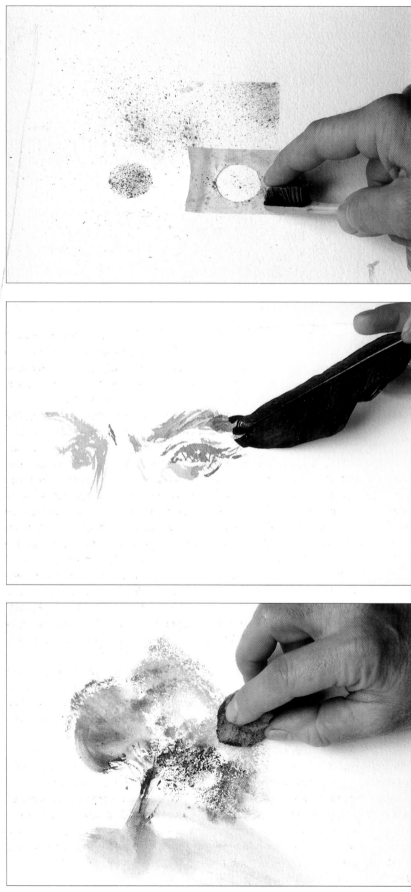

Toothbrush Techniques

A toothbrush can be employed to create splatter textures, and can also be used as a poor man's airbrush. By building up layers of different colours a variety of textures can be achieved. Here I have shown the use of masking tape in order to both protect the work and make specific shapes. Ensure that the brush is held with the bristles vertically, and draw the fingertip towards yourself. By pointing the brush directional control is maintained.

Feather Painting

Although slightly unpredictable, painting with a feather can produce some particularly interesting effects. On this occasion I have used it to paint some eyes in a portrait. By using the edge and the broad sweep of the feather, different marks can be obtained. Manipulation of the quill, by twirling between the fingertips, will create other and equally varied marks.

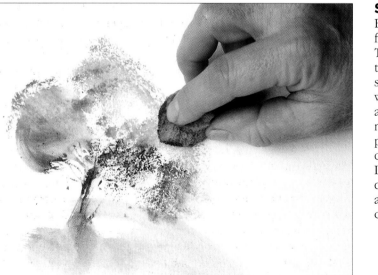

Sponge Work

By using a soft natural sponge further textures can be created. To apply the colour, lightly dip the sponge into the paint and squeeze out the surplus. This will give you a fine texture. For a softer, denser texture use it more fully loaded. It is also possible to paint with a sponge creating soft swathes of colour. Lifting or wiping out is usually done when the paint is dry. Small areas can be masked out to create crisp edges where necessary.

Ragging

Ragging is yet another method by which texture can be applied. Depending on the nature of the cloth used, various textures can be produced. Ragging generally gives you a more open style of texture. For variety, dip the screwed up rag in different colours and then apply to the paper. Ragging can also be applied using soft tissue and crushed paper.

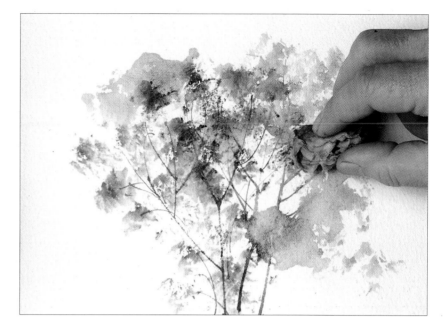

that it will, with care, last indefinitely. Most types of watercolour paper are 'wove', so called because of the woven mesh that the papers are produced on at the paper mill.

For all practical purposes the variation in thickness of the paper is normally reflected in its weight. This weight is indicated in two ways. In can either be in pounds per ream (500 sheets) of a specific sheet size, for example 90lb 30 x 22ins (760 x 560mm), or in grams per square metre (gsm), for example 190gsm. Whereas the pounds per ream weight will vary depending on the sheet size the gsm remains constant irrespective of the sheet size. Thinner papers (90lb/190gsm) are normally for small paintings, or when the painter is using a drier technique. Heavier papers (140lb/300gsm or more) are for working with wetter paint and for large paintings.

When looking at watercolour papers you will notice that they vary in texture. In fact there are three distinct groups: Rough, NOT and Hot Pressed. Rough, as the name implies, is highly textured and is suitable for work where the surface of the paper can be exploited to suggest the character of say rock, bark, crashing waves and so

on. NOT, sometimes called CP (Cold Pressed), stands for Not Hot Pressed. A finer texture is produced using felts, which vary according to the papermaker. This surface is suitable for a fair amount of detail together with texture, and is the most commonly used paper. The HP (Hot Pressed) is the smoothest surface and is particularly useful for detailed work. It is not really suitable for large areas of wash, as these tend to slip and slide about due to the lack of 'tooth' in the paper. Tooth is the amount of texture on the paper surface and it helps retain the watercolour from the brush.

The range of watercolour papers varies in colour from white to almost beige. If the colour is a bright, almost blue-white, then china clay has been added to the mix, which is unsuitable for the watercolourist as this extends the fibres in the paper accelerating its potential disintegration. The china clay will also mix with the paint to give it a murky finish. The other colour variations are due to the water used in the making, which might have minute quantities of tannin and iron oxide. I like a slightly deeper tone for life painting but prefer a whiter paper for

flowers. The water used in paper-making needs to have a low pH value (acid level). You can buy 'Acid Free' papers and these resist the tendency to go mouldy.

The final factor affecting the choice of paper is its absorbency. This is not something you can see so you need to test samples. The absorbency or otherwise of a paper is dependant on the amount of size added to the mix – more size means less absorbency. The more absorbent the paper the quicker it dries and is better for speed painting. However, it is less forgiving and mistakes are difficult, if not impossible, to rectify. A harder paper allows you to move the paint around more and correct any mistakes easily.

When choosing a paper first consider the scale of your work and therefore the weight of the paper. Second, consider the type of painting:

Fine detail = Hot Pressed
Lots of texture = Rough
A little of each = NOT.

If you are a beginner, or want to move the paint about, go for a hard-sized wood pulp. If you want speed with a good finish use absorbent cotton rag.

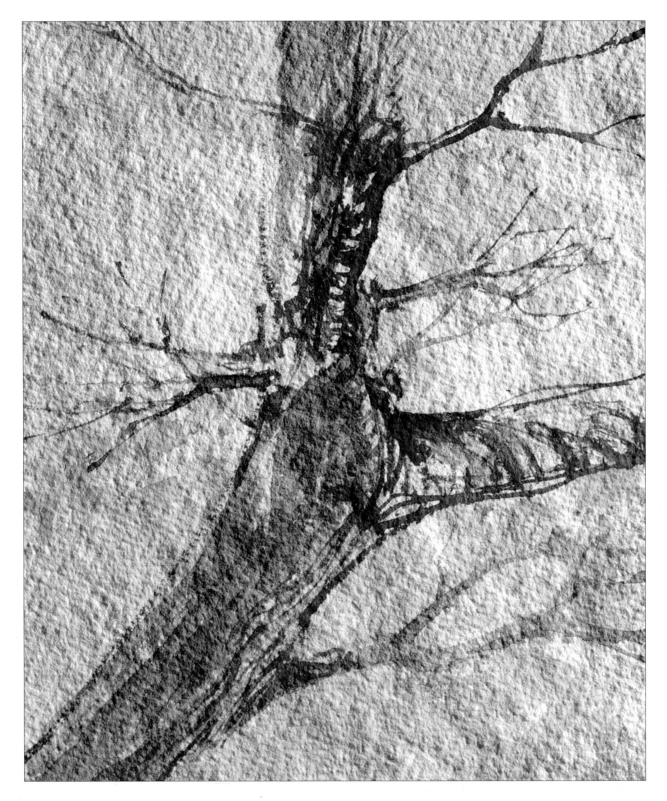

NOT Surface paper

NOT (or cold pressed) stands for not Hot Pressed. This means that the paper has the imprint of the felts used to create the paper. This imprint gives it a certain texture which varies from manufacturer to manufacturer. The best kind of texture is one which is completely random. Textures can also vary in terms of depth making the paper either rougher or smoother.

NOT surface paper is the type of paper used by most painters as it gives the watercolourist the opportunity to do both detailed and textured work. It is also suitable for dry brush work and shows up the nature of granulating or precipitating pigments.

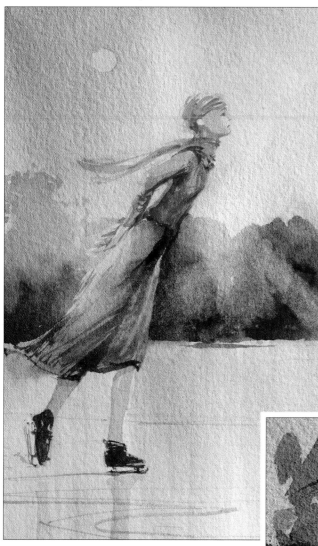

HP Paper

HP stands for Hot Pressed and is a smooth textured paper that lends itself to fine detail work. I use it also for very quick studies which I execute with a round sable. This paper is not really suitable for large areas of wash as the colour tends to slide around on it. However, for botanical work, where delicate tints are employed, it has one of the best surfaces available. Soft sponging also works well for creating depth, and highlights can be added by scraping with a scalpel or sharp knife.

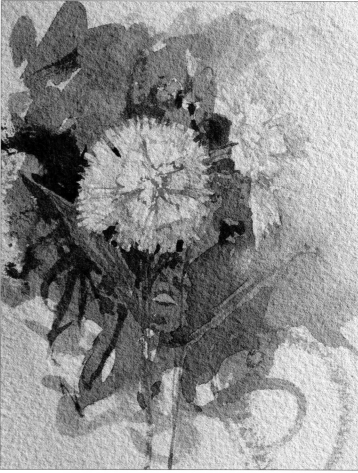

Rough Paper

Rough paper has the most obvious texture, as implied by its name. This paper is not suitable for fine detail, but gives ample opportunity to express various kinds of textures. I find it ideally suitable for foliage, the bark on trees, rocks and the spume from waves. It can be handled with great freedom and many artists find this stimulating as it can give surprising results.

CHAPTER 2

COLOUR CHOICES

Our eyes, the most magical of organs, enable us to see the world in all its myriad colours. From primaries to secondaries and tertiaries the tangled web of information is transformed into shapes that we recognise as trees, people or clouds. The painter puts the colours into juxtaposition to generate excitement in seeing these objects. Nature herself produces colour in a particularly vivid way. Illuminated by the sun the colours have an intensity that the painter can only try to emulate. Colour manufacturers are only able to approximate Nature's intensity so it is incumbent on the artist to use these pigments in an adventurous way, and sometimes exaggerating them in order to bring out Nature's true glory.

BEING BOLD WITH COLOUR

Watercolour painting is unique in the way in which colour is used. In other mediums – oil, gouache and pastel – the way to lighten a colour is to add white pigment but in watercolour the paper provides the 'white'. The addition of water to watercolour paint allows the paper to show through, so in effect water is the lightening medium. It is this simple fact that gives watercolour its special quality of translucency and transparency. Colour manufacturers always use the finest ground pigments and these enable the watercolourist to work from the most intense colour through to the most delicate tones

Perhaps the worst pitfall facing beginners is ending up with a painting that looks muddy. The main reason for this is not fully understanding the chromaticity of the pigments in their palette and the consequences of mixing them. For the purpose of understanding

Daisies with Candle
Here the use of bright primaries shows how vibrant watercolour can be. The paint has been applied with practically no mixing. I often mix colour on the paper rather than on the palette. Colour can also be suggested by the white paper – the daisies are simple, negative shapes. Note that the more delicate greys are mixed and are not a proprietary colour. This mixture uses primary colours and is described in the text.

Courtyard
Colour can be approached in many different ways. I have used an almost pointillist technique of applying the colour. This method uses small touches of paint which, when seen from a distance, are optically mixed. Some painters are nervous of tackling a subject such as grey walls and green trees. If seen in a more colourful way this kind of subject matter can prove very exciting.

Stream
The colour here has been applied in a somewhat different manner – in stripes which interweave. This is a system used by Van Gogh and it extends the idea of optical mixing. For example, certain greens can be produced by interweaving yellow and blue stripes. This means that the artist is can work much quicker as they do not have to spend time trying to obtain a particular hue but rely instead on visual blending.

colour there is a basic system that groups the main kinds into three. These are primaries, secondaries and tertiaries. Primaries are red, yellow and blue. Secondaries are orange, violet and green. Tertiaries are grey, brown and beige. I will deal with each of these in turn.

The difficulty when talking about colour is the language. In some ways we do not adequately understand our response to colour. The perception of colour is a physical sensation brought about by what the retina of the eye receives, then through neuro-chemical means it is transmitted to the brain. Our eyes are a part of our defence mechanism so the brain reacts to codes received by the eye. All we see is a series of messages in colour. Experience tells us what to be afraid of and what to be attracted to.

When an artist is trying to attract the attention of the viewer primary colours are the strongest stimulus available. However, there is no such thing as an absolute red or yellow or blue. Primaries are subject to all kinds of influences – atmosphere, ambient lighting and reflections are just a few that will alter their hue. For example, red can be subtly biased towards either yellow or blue, yellow to blue or red, and blue to red or yellow. You may well have three or four reds of which some are biased towards blue and others towards yellow. Knowing all this helps considerably when it comes to colour mixing. The names colour manufacturers give to paints are mainly traditional and often have no bearing on their

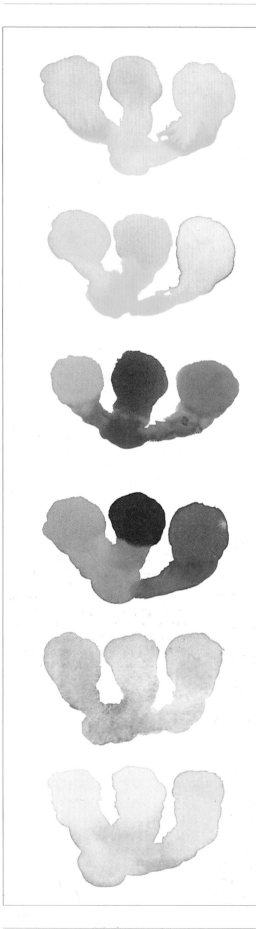

Neutral Colour

Beige

Beige is a tertiary colour which is yellow biased.
The group on the left has been mixed using cadmium yellow. Cadmium yellow has a little red in it, therefore it only needs a small addition of blue to neutralise it. Blue can be added in subtle ways. The right hand leg has simply had lemon yellow added, which has a blue biase. The middle leg has a small amount of mauve added, and the left hand leg some permanent rose (blue biased).

This group uses a blue biased lemon yellow as a base. To counter this a small amount of red is required. The right hand leg has red added by way of cadmium red, the middle leg with permanent rose and the left hand leg with cadmium yellow, which has a small proportion of red in it.

Browns

Browns are a red biased tertiary.
The group on the left has been mixed using a blue biased rose. This needs modifying with a small quantity of yellow; the right hand leg with cadmium red, the middle leg with phthalo blue and the left hand leg with lemon yellow. These three primaries have a proportion of yellow in them.

This group has been mixed with a yellow biased cadmium red as a base. It thus needs modifying with a little blue; the right hand leg with permanent rose, the middle leg phthalo blue and the left hand leg with lemon yellow. These three primaries have a proportion of blue in them.

Greys

Greys are a blue biased tertiary.
The group on the left has been mixed using a red biased ultramarine blue. To modify this a little yellow is required. The right hand leg has been modified with phthalo blue, the middle leg with lemon yellow and the left hand leg with cadmium red. These three primaries have a proportion of yellow in them.

This group has been mixed with a yellow biased phthalo blue. To modify this you will need a proportion of red. The right hand leg has been modified with ultramarine blue, the middle leg with cadmium yellow and the left hand leg with permanent rose. These three primaries have a proportion of red in them.

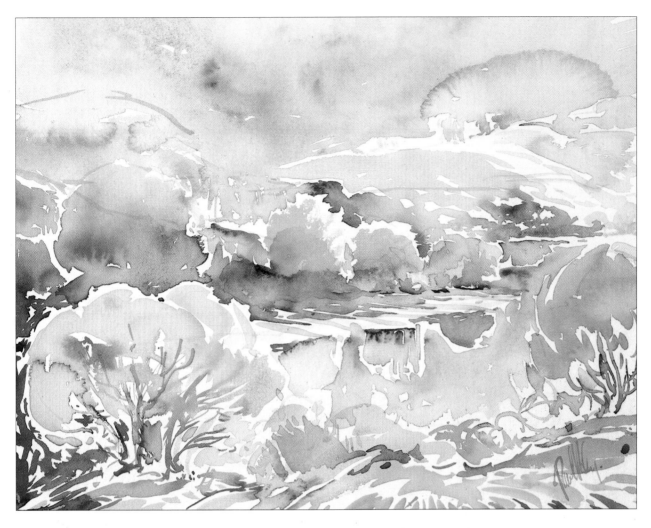

contents. Cadmium red, say, has no cadmium in it but is made from chemicals that produce a pigment that looks like cadmium red used to! To avoid confusion I open the tube, or consult their colour charts, and look at the specific hue. This is important as, depending on the manufacturer, cadmium red varies considerably due to the amount of yellow present because cadmium red is yellow biased.

Mixing two primaries produces a secondary, for example red and yellow mix well to give orange. But is this so? In fact it depends very much on which red and yellow you select. For a true secondary orange you need to mix a red with a yellow bias, for example cadmium red with cadmium yellow. If you mix a blue biased red (alizarin crimson or permanent rose) with a blue

biased yellow you will produce a brownish or tertiary orange because you have in fact mixed red, yellow and a proportion of blue. I have often seen people trying to mix a violet using cadmium red and any old blue. The result is a disaster due to the yellow present in the red. The only way is to use a blue red (permanent rose) mixed with a red blue (ultramarine). The same applies to greens. The reason why so many landscapes lack sparkle is that the greens are nearly always tertiary, that is mixed using a red biased yellow. To obtain a true secondary spring green you have to use a yellow blue (phthalo) with blue yellow (lemon). Needless to say colour mixing is a sensitive process and any adulteration by way of dirty water, palette or brush will considerably affect the hue and

River View
In this landscape study all the delicate tertiaries were mixed using primaries. The beige colours are yellow biased, the browns red biased and the greys blue biased. Pigment was added to the river to obtain the different tones. Much of the colour mixing can be achieved on the paper itself, and colour modification can then take place whilst the pigment is still wet.

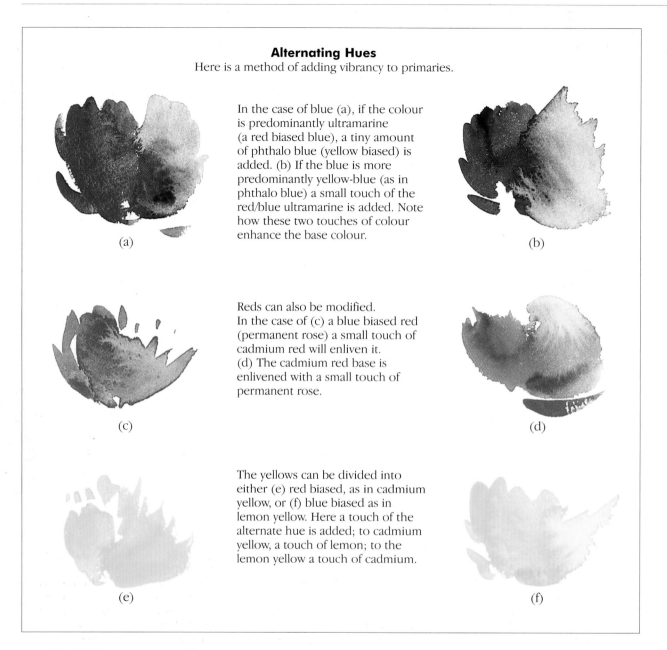

Alternating Hues

Here is a method of adding vibrancy to primaries.

In the case of blue (a), if the colour is predominantly ultramarine (a red biased blue), a tiny amount of phthalo blue (yellow biased) is added. (b) If the blue is more predominantly yellow-blue (as in phthalo blue) a small touch of the red/blue ultramarine is added. Note how these two touches of colour enhance the base colour.

(a)

(b)

Reds can also be modified. In the case of (c) a blue biased red (permanent rose) a small touch of cadmium red will enliven it. (d) The cadmium red base is enlivened with a small touch of permanent rose.

(c)

(d)

The yellows can be divided into either (e) red biased, as in cadmium yellow, or (f) blue biased as in lemon yellow. Here a touch of the alternate hue is added; to cadmium yellow, a touch of lemon; to the lemon yellow a touch of cadmium.

(e)

(f)

rapidly turn it to a mud. I advocate having a piece of paper (of the same type you are using) on which to test colours. Remember that even the colour of the paper can effect the hue. You can also use a scrap of paper to hold up the colour you are trying to match against the actual subject matter. Remember you adjust the tone (from dark to light) by simply adding water.

How do you darken primaries without losing their intensity? The old traditional way was to simply add black, which certainly darkens

but robs the colour of all its intensity. Generally speaking, a colour darkens through the absence of light and therefore moves towards the blue scale so the basic way is to add blue to a colour to darken it. There are various ways of adding blue either directly or more subtly. For example, to darken a cadmium red (say the colour of a poppy) you can add progressive amounts of permanent rose, which is a red with blue in it. To make it darker still add small amounts of mauve, which will make it very dark indeed with no loss of intensity.

Darkening blues is simply a case of working up to the full strength of the pigment until you get it practically black. In this case I use the darkest blue (phthalo) and cancel out its hue (blue) by adding the darkest red (alizarin crimson). This is a good way of making a black that you can make lean towards either the red or blue scale depending on your subject matter.

The trickiest colour to darken is the yellow, for example the shadow area inside the trumpet of a daffodil. It is so easy to make it look dirty. If you look closely you

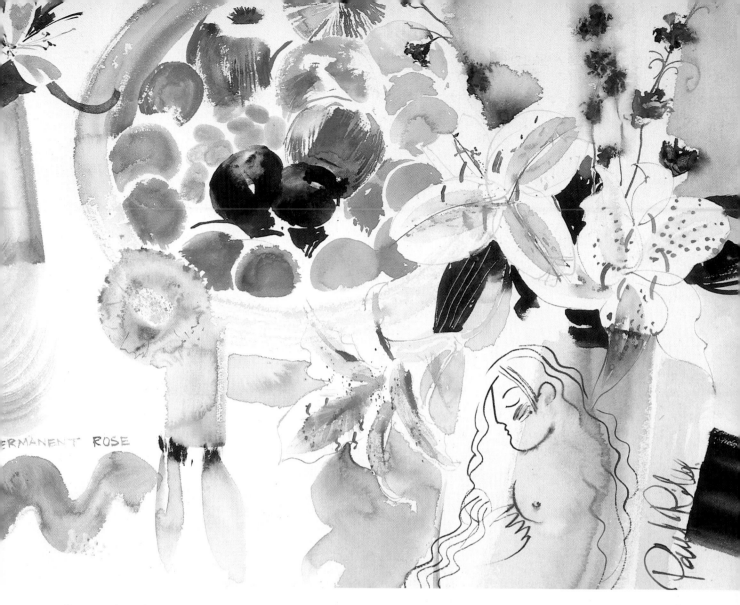

PERMANENT ROSE

will notice the colour seems to be a cross between orange and green and that is what I mix. I use a true orange (cadmium red and cadmium yellow) and a true green (say lemon yellow and cerulean) and put them adjacent to one another and allow them to slightly merge. I do this when painting lemons, grapefruit, clothing and so on.

Painting with only primary and secondary colours has been practised for a long time, notably by the Impressionists and the Fauves. The French painter Seurat developed a method he called pointillism which used dots of primaries to build up a whole range of hues. Dots of yellows and reds, when seen from a distance, optically mix and produce orange. I often like to paint apply this principle and use stripes, dots and dashes of primary

and secondary colours to produce very vibrant images.

However, not all painting is about whizzes and bangs. There are times when you need to introduce a little subtlety into your work and this is where we use tertiaries. Tertiaries, sometimes referred to as neutrals, are a result of mixing the three primaries – red, yellow and blue. (There are one or two schools of thought who differ from this. However, my experience over the years makes me believe it is so!). These colours also break down into three distinct groups based on the primaries – *grey* (which veers towards blue rather than red or yellow) is blue biased, *brown* is red biased and *beige* is yellow biased. I am a great believer in mixing tertiaries rather than using proprietary colours such as

Permanent Rose

All the primaries – red, yellow and blue – have been uplifted by the introduction of their alternating hue (see page 34). Notice, when looking at the lilies, that the general blue-red colour of the petals has been given a little zing with the introduction of a little cadmium (yellow biased) red.

Payne's grey, blacks or earth colours. Certainly several of the earth colours offer a short cut but I feel it is best that you develop the skill in controlled colour mixing rather than taking the quick fix. For example, you may wish to use greys for tones of mist and fog over early morning water. These can be controlled to give a green, red or blue bias to suit adjacent colours. I

Complementary Colours

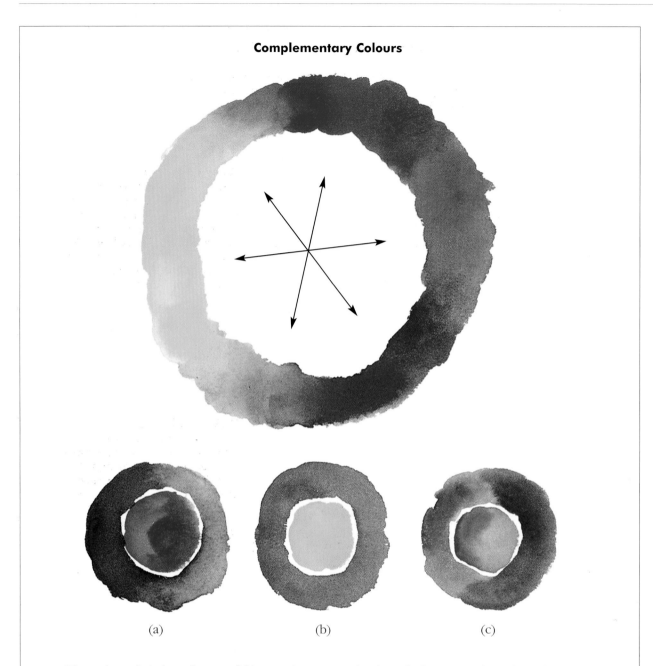

(a) (b) (c)

The coloured circle at the top of this page is what I describe as my 'Donut'. It is possible, as you can see, to change a colour from red to blue by moving it through a permanent rose and then a violet phase. Blue can merge to yellow through a green phase, and yellow merge to red via an orange phase. In sequence, the colours I have chosen to show this are cadmium red, permanent rose, ultramarine blue, phthalo blue, lemon yellow, cadmium yellow and back to cadmium red again. The complementary colours are the ones seen directly across the donut, so opposite the red you have green, opposite the orange you have blue, and opposite the yellow you have violet.

The three 'bull's-eyes' indicate how the complementary colours work. (a) The centre has a red which is yellow biased on the left side and blue biased on the right. The surrounding green complements the yellow biased red with a blue-green and the blue biased red a yellow-green. (b) Here the centre has cadmium yellow on the left side and lemon yellow on the right. The surrounding violet complements the cadmium yellow (which is more red) with a blue-violet and the lemon (which is more green) with a red-violet. (c) In the case of the orange centre the surround on the red biased side of the orange is a green-blue, and on the yellow biased side of the orange a more red-blue.

Complementary Neutral Colours

Complementary neutral colours are used to enhance the
primary colours. They help a principle colour, for example
red, to come forward and give it a certain resonance.

Red and Green

The red is divided into cadmium
red on the left and permanent rose
on the right. A complementary
neutral is a green-grey. The green-
grey adjacent to the cadmium is
slightly more blue, but the green-
grey next to the permanent rose is
slightly more yellow.

Yellow and Green

Here the yellow is divided
into lemon yellow on the left and
cadmium yellow on the right. The
complementary neutral is violet-
grey. The violet-grey next to the
lemon yellow is slightly more red
whereas next to the cadmium
yellow the violet-grey is slightly
more blue.

Orange and Grey

To provide a complementary
neutral to the orange the grey must
have a blue bias. The blue is
adjusted to complement the
adjacent orange. In the case of the
redder area there is more blue in
the grey and next to the yellower
orange there is less blue.

Tree Study 1
To be truly bold I have painted this small scene using only primaries and secondaries. This produces a very vivid combination which I have further enhanced by deliberately separating the colours one from another, allowing very little merging. Note the complete absence of tertiary colours which would tend to reduce the impact of this image.

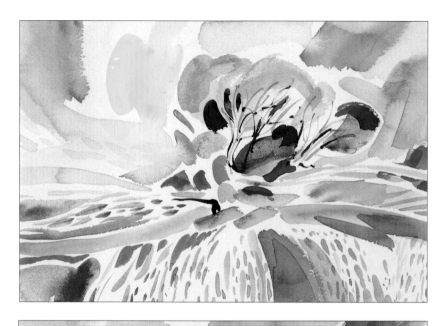

Tree Study 2
This is an equally powerful statement but this time there is something strange about the colours. Here I have repainted the top image using complementary colours. For examle, where the tree was orange, it is now blue, green grass turns to red, blue becomes orange. Painting with complimentary colours can create interesting and unexpected juxtapositions. If you have what seems a boring scene in front of you then use complimentaries to create an entirely different atmosphere.

will expand on this when dealing with complementary colours. When mixing a grey the first thing to consider is what blue to use as a base colour. It can be a yellow bias blue (phthalo) or a red bias (ultramarine). The bias will determine how it is to be neutralised. In the case of phthalo all that is needed is a touch of red. If you want a grey to be particularly blue all you need is a touch of ultramarine. Remember this colour already has a suggestion of red in it. A touch of yellow and a touch of red gives you a tertiary blue biased grey. I hope this gives an indication of how subtle you can be with colour mixing.

Another example – start with ultramarine blue (red blue) add a tiny touch of cadmium yellow (red yellow). Theoretically you will have a green. However, if you increase the amount of blue it will turn into a grey, albeit a precipitating one (see under pigment behaviour). You have to remember that that colour mixing is like cooking. You cannot make boiled potatoes with two pounds of potatoes and two pounds of salt. It is two pounds of potatoes and a pinch of salt. Colour mixing is much the same – sometimes the merest touch is all that is required to adjust a hue.

Adopt the same kind of strategy

with browns. Start with a red, but bear in mind which kind of red. If it is yellow biased adjust with blue, if blue biased adjust with yellow. Remember you are always mixing three primaries. Beige is that wonderfully subtle colour which many painters find quite elusive. Again start with the main bias, in this case yellow, check which particular hue and then adjust with either red or blue. Time spent experimenting with these mixes will reward you with a skill in colour matching. Your responses will become natural and even instinctive because they will be based on experience and not a stab in the dark.

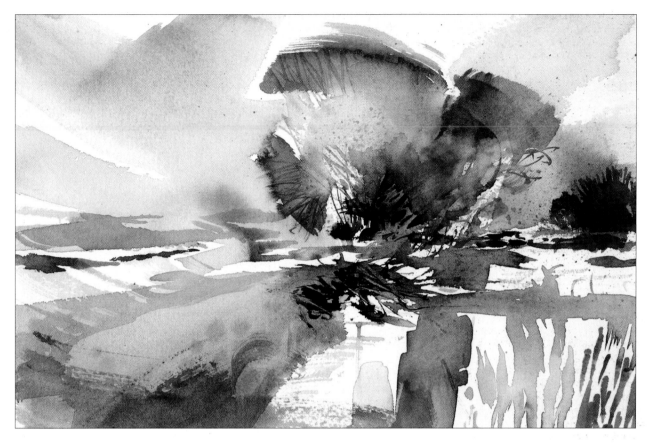

There is a way of adding even more sparkle to your colours by using a method I call 'alternating hues' (see page 34). I have often found instances when painting flowers of a particular hue, say a blue red, that the result has looked a little drab. I may have balanced all the tones correctly but somehow they lacked that vibrancy that nature endows. It was not until I accidentally put in a touch of the opposite hue, a yellow red, that the whole image came to life. What occurred to me was that my eye was instantly attracted to the fact that the red was shimmering due to the presence of three colours – the main red plus the small amounts of yellow and blue! I discovered that if the predominant red were blue biased, I only needed a very small amount of the alternating colour to give the effect. Naturally I was excited by this and wondered if it worked the other way around, and sure enough it did. A yellow red (cadmium) with a

small touch of blue red (permanent rose) works as well. I then tried with both types of blue, red biased and yellow biased, and found the result to be equally satisfactory. Needless to say when I tried with the yellows I was not disappointed. Maybe every other artist in the world knows about this phenomenon but I have not heard it expressed.

So far I have referred to colour as individual elements in a painting, but to create a painting you must put one colour adjacent to another. This is basically what painters are trying to do – be they abstract or figurative painters. It is when you put one colour against another that things begin to happen. The only other thing that matters is the quality of edge – be it crisp as in close up detail, soft as in middle distance or suffused as in far distance.

A fact that has always fascinated me is the way in which a specific colour like red, for example, with a

Tree Study 3
Finally, I painted the subject using only neutral colours – brown, grey and beige – which were mixed using the primaries. The near blacks, for example, were made by mixing ultramarine blue with phthalo blue. I also tried to enhance the neutrals by placing complementaries adjacent to one another – sienna yellow against a violet grey, and green greys against red browns and so on. Painting with subtle, neutral colours does not necessarily mean that you have to produce muddy paintings. With careful mixing beautiful colours can result.

small addition of blue can be transformed into mauve then to violet through to blue. This change can be represented in the form of a circle where a red can transform to blue then yellow then back to red again via the secondaries violet, green and orange. This phenomenon has been well recorded and is

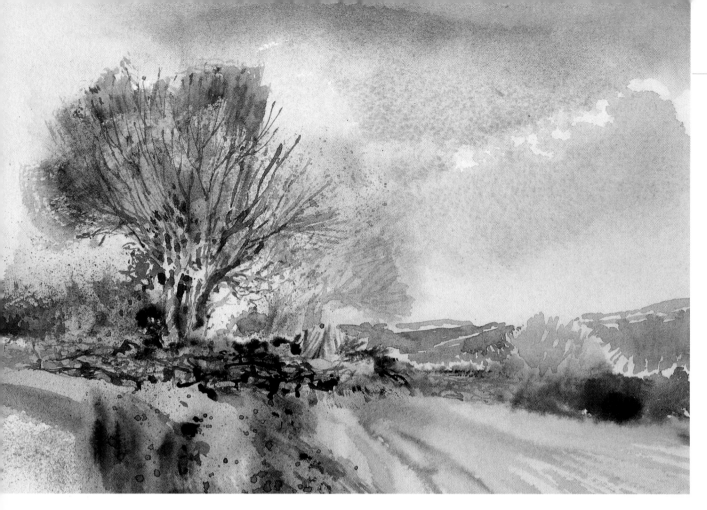

Hedgerow

In this painting I have deliberately selected a range of different pigment types. Because there is a lot of texture in the stone wall and foliage I have used precipitating pigments. For the delicate sky washes I applied stains, and for the hills and dark tones in and around the trees I used dense and semi-opaque pigments. Subtly varying the pigment types can add a further dimension to your work. The sequence is also important. I tend to lay the stains down first to give a foundation to the painting. When this has dried subsequent overpainting can be done, and details added by using dense pigments. Any textures can also be added later using granulating pigments, either over white paper or over existing stains.

often referred to as a colour wheel. It is interesting to note the colours that lie opposite each other on the wheel. For example, opposite the red is green, opposite blue is orange and opposite yellow is violet. In fact opposite each primary there is a secondary colour made up of the other primaries. When these two colours are placed adjacent to one another a scintillating effect takes place which attracts the eye quite forcefully. The term used to describe this colour in conjunction is 'complementary' and is used by painters to enhance their work and arrest the viewer's eye. To obtain the greatest effect the two colours need to be of the same intensity, with crisply defined edges. Another way of using complementaries is by way of enhancing a particular colour. The way I do this is to use a tertiary form of complementary. For example, if placed adjacent to a yellow a pale violet grey will up the value of the yellow. A blue grey will have the same effect on orange, reddish

browns on greens and so on. You may have wondered how to perk up your seemingly dull green landscapes. My solution is to find and put small touches of red and rich browns to complement the greens. Notice, for example, the amount of red in the landscapes of Constable and the Impressionists. If you have a passage in your painting where the hue alternates, say yellow red through to blue red, note that the complementary green will alternate also. When adjacent to the yellow red the green becomes more blue, against the blue red the green becomes more yellow. You can see how this works on the colour wheel when you read across from any particular colour. Subtle adjustments to your work can be made when using the tertiary complementaries.

None of the above are intended to be hard and fast rules. On the contrary, if it were painting would be a dull and scientific process. All I have intended is that you think about colour and its mysteries and

Pigment Behaviour

To the right is a selection of pigments which vary in type and behaviour.

Row 1. These are stains. From left to right, the yellow is arilide-lemon yellow, the red quinacridone- permanent rose, the mauve is rhodamine and the blue is phthalocyanine. Stains are suitable for clean, clear transparent hues such as flesh colours and petals.

Row 2. These are dense (semi-opaque) pigments. From left to right they are cadmium yellow, cadmium red and the earth colours – burnt sienna and raw sienna. Dense pigments have good covering power and are best used for subsequent detailing. The drawback with them is that overwashing can sometimes disturb them.

Row 3. These are examples of granulating (precipitating) pigments. From left to right they are raw umber, cobalt violet, manganese blue and ultramarine. Precipitating pigments are ideal where additional texture is required, for example in landscapes. They are not suitable for flesh tones.

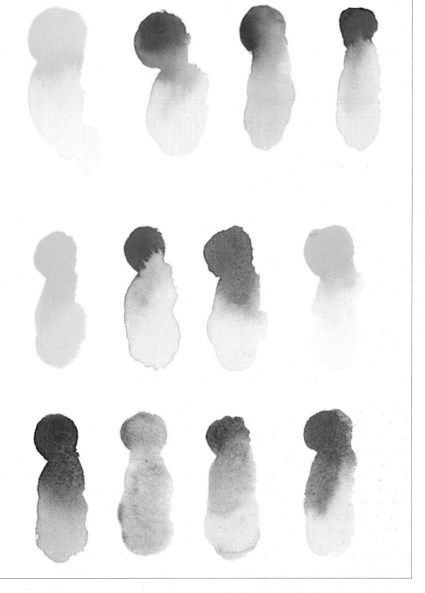

use the information to help rescue areas in your work which may seem empty and lifeless.

Another factor that affects colour, and is peculiar to water-colour painting, is the nature of the paint itself. Because the pigment is diluted with water different types react in different ways. Again there are in fact three distinct kinds; stains, opaque/semi-opaque and precipitating/granulating. Their effect on paper is quite significant and needs to be understood if you are to avoid a mess. Watercolour paper has a certain degree of absorbency and in the case of NOT and Rough surfaces (see Chapter 1) they have a texture that shows the effects of the three pigments. Stains have a minute particle size that passes through the paper fibres and sets into the body of the paper. Opaque or semi-opaque pigments have a larger particle size and tend to sit on the surface of the paper and have a certain cover-ing power. The precipitating/gran-ulating particles are the largest and they sink into the valleys of the paper's surface texture. There are good and bad aspects to these behavioural patterns. Stains are good because they have clean, clear, transparent colours suitable for flesh, flowers and skies and do not move about when you have applied them. The downside is if you use bright or dark stains and inadvertently put them in the wrong place they are almost impossible to remove.

Opaque / semi–opaque pigments have good covering power and have enough density for detail work (best applied late in the work). They are also good for lifting. However, it is difficult to apply overwashes as they tend to stir up the under colour which can result in a muddy finish. They can also

Wild Garden
This painting reflects an altogether different mood. The choice of colours and the method of handling indicate a sense of joy I felt at the arrival of summer. Primary colours and secondary colours abound. What I was also looking for was the way that nature produces an inordinately complicated pattern of colours which are jigsawed together in a convoluted way. In order to make sense of the confusion I broke the seemingly complex areas into zones. These zones were handled in different ways from small touches to v-shaped touches and larger strokes which, when interwoven, give the sense of nature's rambling style.

reduce that transparent translucent quality you need in watercolour.

The precipitating/granulating pigments are ideal for texture, such as foliage and rocks. Care must be exercised because they can easily make certain elements in a painting look muddy. They are best avoided for flesh, flowers and clear skies (although good for stormy skies) and clean shadows (good on buildings and ground). The question I get asked often is 'How do I know which is which?' There are two answers. You can check the manufacturer's literature where quite often they tell you. Failing that, the second option is by observation. Apply full strength pigment, let it dry then try to remove it. If it is stubborn then you have a stain. If it lifts easily and also looks dense then it is likely to be

opaque/semi–opaque. If, however, when dry it has granulated then it is a precipitating/granulating pigment. After a while familiarity and experience tells you.

Landscape painting can sometimes be fraught with a certain sameness of colour that results in a rather bland offering of greens and browns that fail to excite. A technique I use to stimulate the eye, and therefore the colour, is to indulge in an exercise of adventure. The method is to first produce a drawing in which all the zones are clearly defined – a bit like a jig saw puzzle. The next thing is to define all the colours of the respective zones into either primary or secondary colours. In a still life this is relatively straightforward but in the case of a landscape this might be trickier due to the fact

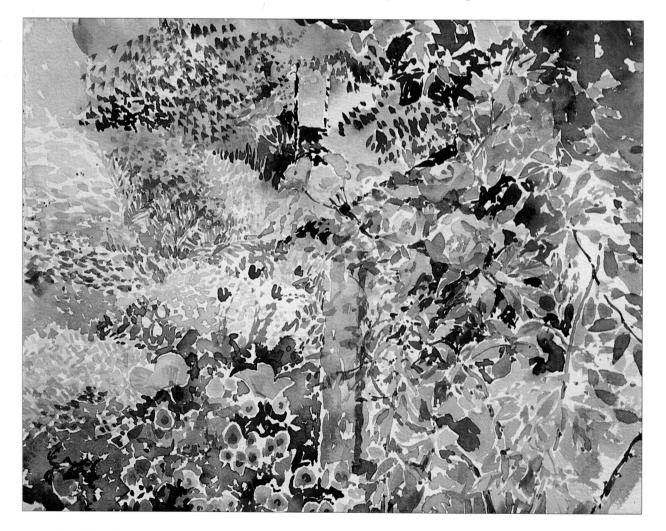

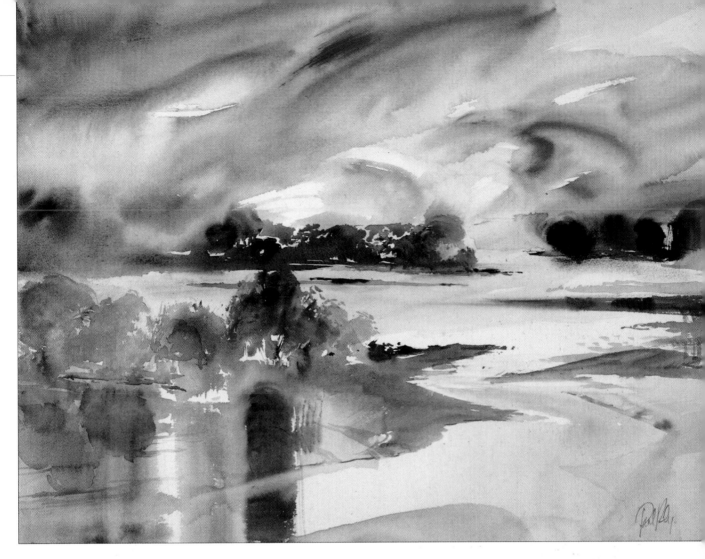

Mood River

It is always best to plan a colour theme rather than just paint what is before you. Mood may well influence this choice. You will notice, for example, how morning light is completely different from that of the evening. Reflecting this can give a special quality to your painting. Weather may also play a part. Colours have a particular vivedness after a storm. A further influence is the location itself. Trying to express the mood of a river and the way in which it flows will sometimes affect you choice of colour. Your inner mood is also a major factor. Anything that affects you is likely to make you see the subject in a particular way. In this painting I am trying to get a balance between tranquility and movement. My colour choice therefore reflects this.

that many of the colours may be tertiary in nature, that is browns and greys. In this situation I make the greys either blue or violet, and browns either orange or red. This makes the colours more dynamic. I then give the colours a tonal value of two or three, three being the darkest. With all this information I prepare a painting by drawing out the zones in colours representing the annotated colours. These are then freely filled in with hard or soft edges and with alternating hues where appropriate. The result is bold, bright and certainly dynamic. The next stage is even more stimulating. I now re-annotate all the colours to their complementaries, thus blue sky becomes orange, green grass is red and so on. The effect of this is that all the preconceived ideas of what certain items in a painting should look like have now been dislocated. Red trees, orange skies, yellow shadows.

These all stimulate ideas about how you can completely readjust colour according to your fancy.

The final experiment is to use the information gleaned from both studies to do a further version of the same image using your favourite colour relationships.

Most people find it hard to stretch the imagination when it comes to landscapes, and even more when doing portraits or life painting. The tendency is to go for the local colour you see before you – green and brown for trees, or pink for flesh. However, when painting you have to compress what you see in nature and in some ways exaggerate the colour to make it seem more real. It is only when you stare really hard that you can 'see' these colours. Yes - blues, greens, oranges, violets can be seen in flesh tones!

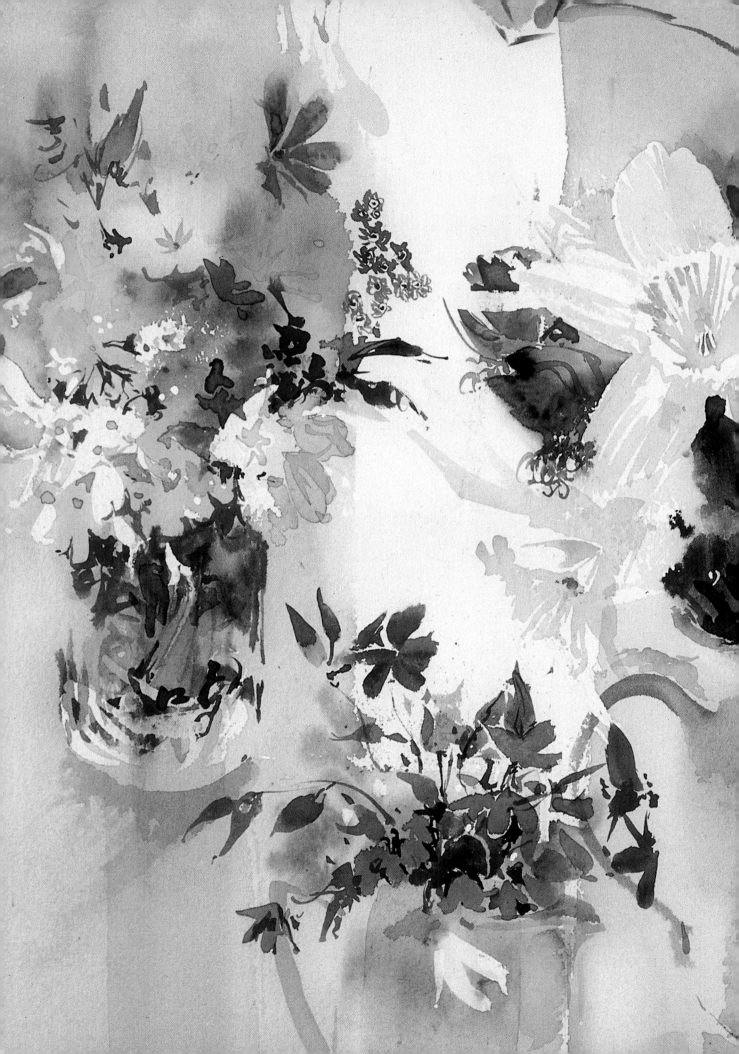

CHAPTER 3

COMPOSITION

When I first heard the word 'composition' applied to painting I thought of music and how composers apply their craft. In many ways I tend to think like them. In music the composer takes the listener on a journey, via sounds, to all kinds of magical places and reaches a climax that can either be a crescendo or perhaps a calm finale. Music can evoke many kinds of feelings, and so it is with painting. Painters use their basic tools to weave a web of interest and surprise, culminating in the display of the focal reason for the painting. I call this focal point the 'what'. What is it that excites us to set out on a complicated and sometimes frustrating task? Let us explore this intriguing process and unravel its mysteries.

STILL LIFE AND FLOWERS

COMPOSITION

Even when you have the technical ability to paint a picture it does not always follow that a good picture will result. To simply record a facsimile is not enough. This is often proved when a photograph is taken which, though accurate, looks sterile and uninteresting. In spite of all the technical mastery something else is required. That something, to my mind, involves several elements that come under the term 'composition'.

As the word suggests, it is putting all the disparate elements in a painting – such as line (edge), colours and tones – into some kind of order. Bear in mind that, as a painter, you are making a *selection*. What you choose to leave in or leave out is the difference between a painting and a photograph. This selection process dictates that you confine yourself to the essentials that reinforce your basic idea. The 'basic idea' to me is the 'what' of a painting. What exactly stimulated you? What was it that particularly interested you? What element encapsulates your feelings? This 'what' can be anything from a single flower to a central character amid a seething mass of figures, or even a simple abstract shape.

Whatever has caught your eye the viewer must be stimulated by your interest in it. The 'what' is often referred to as the centre of interest and as such is placed in the middle region of the painting. I say region because to place it in the exact centre can cause problems, specifically that of symmetry. If you place the emphasis in the middle the natural tendency is to counter-balance in equal measure with

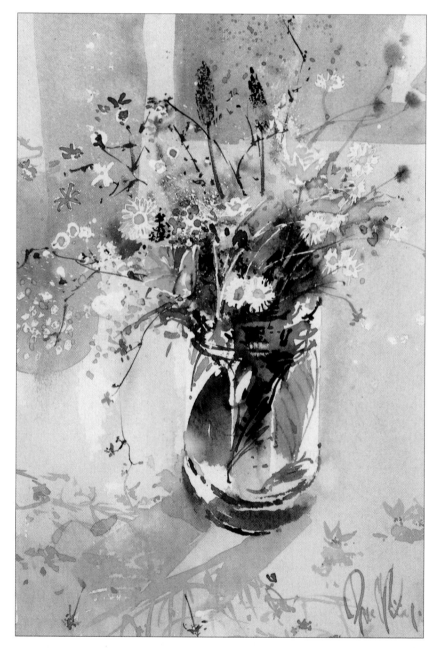

Wild Flowers in a Jam Jar
The most common format for a flower composition is a vertical one. When setting up notice whether the bulk of the flowers are more to the right or the left of the container. If more to the left, as in this case, then position the container to the right to counter-balance them. Balance is a central tenet of composition. In order to relieve a potentially monotonous background area compose the flowers so that they go off the picture plane. This will reduce the background to smaller zones, which can be easily broken up by shadows.

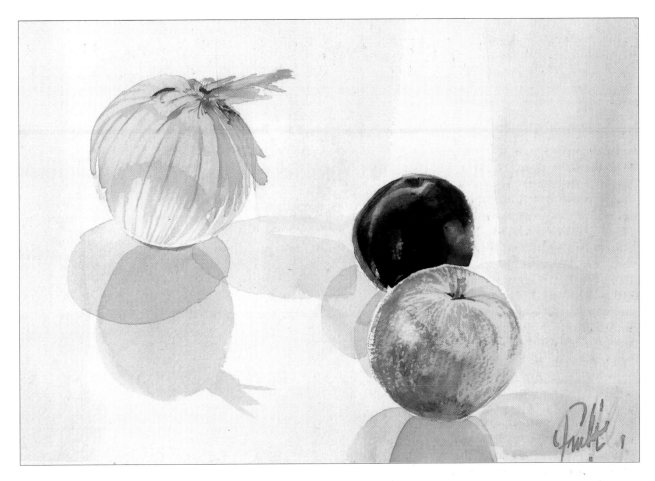

shapes and colours on both sides. This is due to our innate sense of balance. Most primitive painting displays this tendency and this is also the basis of pattern making. This symmetrical approach has its drawbacks in so far as the options for experimentation are limited. If, however, you move the centre of interest to one side of the centre of the painting then the counterbalance exercise has more options.

One of the most important elements in composition is that of variety. Variety in shapes and their disposition, tones, textures and colours. It is the variety in painting that stimulates the painter, then in turn the imagination of the viewer. For example, if a flower painting had flower heads that were the same size, the same distance apart and the same colour the result would be monotony. If, on the other hand, you introduce perspective and overlap the flowers,

vary their size because of their proximity to the viewer and soften edges in the distance. Immediately you have variety and thus generate interest. This brings me to scale, more specifically the scale of your centre of interest. The three things that you need to establish at the outset of a painting are the *what*, *where*, *how big* of your centre of interest be it a flower, the eye in a portrait, or a church. *What* is it that excites you, *where* are you going to place it in the composition and *how big* is it going to be? To establish the *what* you need to know certain fundamentals. For example, in a flower composition it is always the nearest that dominates. In a landscape it could be a specific object such as a building or a tree in the middle ground. In a portrait one of the eyes will command attention. To determine the *where* of your object sometimes it helps if you determine in

Fruit with Onion

A beginner can derive great pleasure from organising a composition using very simple elements. The purpose of the exercise is to achieve some degree of balance. To begin with you can simply play around until you 'feel' that it is right. This 'feeling' is very important but some rules do apply. The darkest and strongest tone needs to be in the main zone of the painting, but not absolutely in the middle. To counterbalance this you can use larger shapes with more or less interest. Another factor in the painting is the white paper itself. There should not be too much of it – sufficient only to give the major objects some weight. Notice that even the shadows perform a function. The purpose of the composition is to relish each object for its individuality but, at the same time feel that they are all in some way connected.

which direction it is looking. Flowers, buildings and people have faces that look left, right, up or down so it is possible to give them space or even objects to look at.

None of the above are hard and fast rules – after all to be creative you need to be original. The primary objective for these thought processes is to prevent you from rushing into a painting and then finding that the composition will not hang together. This usually occurs two thirds of the way into the painting when it is too late to do anything about it. The usual solution is to crop great chunks off the painting to decide what, if anything, can be salvaged.

Having established your centre of interest, its size and placement, (which can be worked out in a preliminary sketch), the next phase of the operation is to take the viewer's eye on a journey of discovery. This is done by the use of lines, but first it must be understood what I mean by lines. Normally lines are taken to be long thin marks produced by a pencil or pen, be they straight, curved or squiggly. In a painting these lines are edges where two tones or colours abut. So, for example, the edge of a table seen against the background of a floor would produce a strongly defined straight edge or a strong line. These edges or lines have the effect of 'drawing' the viewer's eye along their length. Edges vary considerably between cleanly defined straight ones to soft curved ones and even hazy meandering ones. You can also have a line of objects which have the same purpose of drawing the viewer's eye. A crisp straight line will do it directly, forcibly even; a wriggly one will be slower and involved. The artist plays with these edges to direct the viewer to various parts of the painting and ultimately towards the centre of interest. It is important that when planning your painting you are

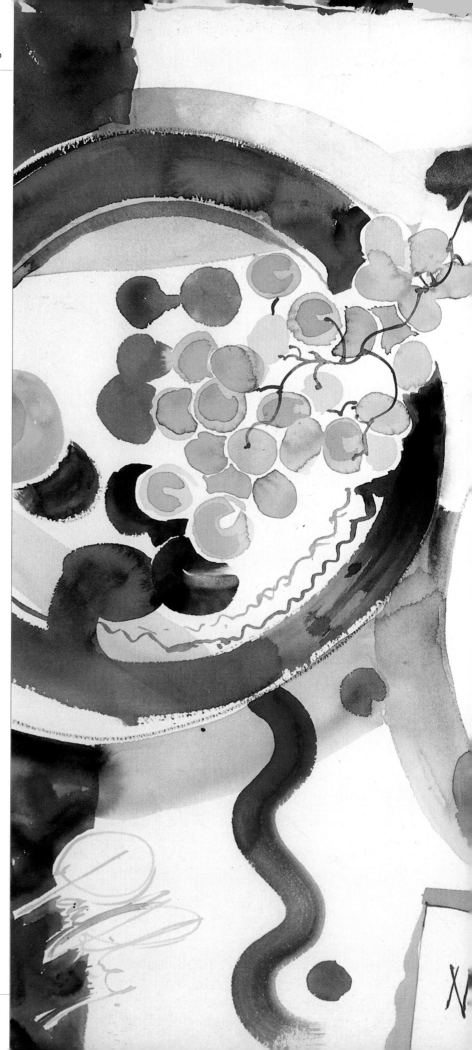

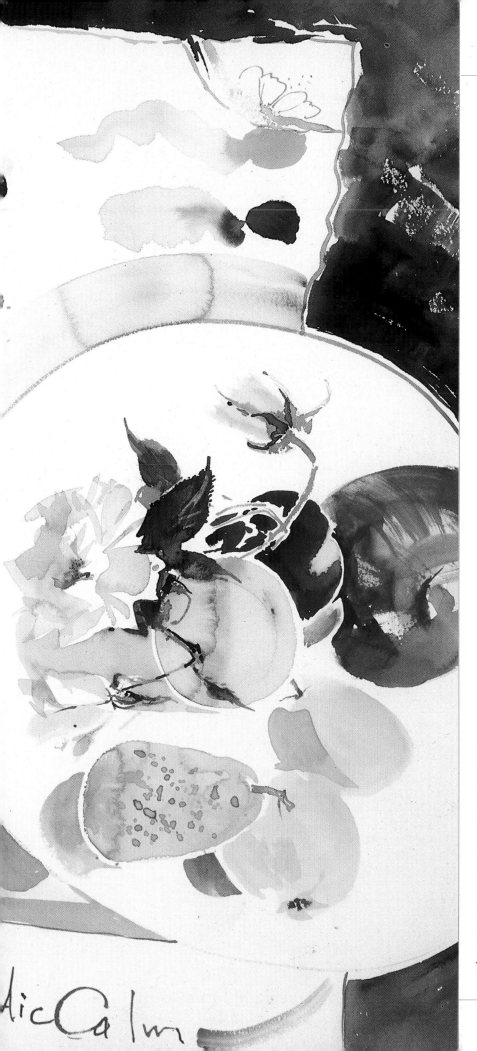

aware of these edges and the consequences of their inclusion.

The joy of still life painting is that in arranging objects and plants you can manipulate these items to produce a balanced composition. This is why I often adopt the plan view, looking down, so that I can engineer a variety of shapes and colours to suit a compositional idea. The main thrust of a good composition should be simple. Terms like cyclic, triangulated and cruciform basically mean that an arrangement might be based on a circle, a triangle or a cross respectively. These simple devices are mainly used to group a complex and seemingly random collection of shapes to form some kind of unity. It is this unification that artists use to get across their ideas as strongly as possible. I imagine basic geometric forms have been used since Euclid. The circle, rectangle, triangle, trapezoid, cone and more have all been used. Once you get the idea it is not long before you start to combine these forms. A simple circle could be linked with a triangle and so on. For example, imagine a rectangular table with three vases of flowers on it. You have the discipline of the table's rectilinear form to contain the subject area. Within this form

Nordic Calm
In this painting I have played a game with the composition that involves circles and rectangles. The circles have been broken by the edge of the picture and this draws the viewer's eye into the composition. This also happens with the edge of the white tablecloth. Within the major circles are the subsidiary elements of fruit, grapes, pears, apples and so on. All lead towards the focal point – the rose – which is a single, irregular shape. To paint a still life like this you need a high eye-level so that you can look down on the objects as a plan form. This can generate interesting geometric views.

Stage 1
I have gathered a collection of different objects which I arrange to surround a focal point. This focal point is to be light-toned and rather delicate, and the objects surrounding it much more dominant. I have separated the objects so that the viewer can relish each one in turn. Rather than use complex drawing-in I have gone in directly with the brush, producing full shapes in one go. For the glass vase onthe right of the picture I applied masking tape and broad-brushed between the tape to produce a soft glow.

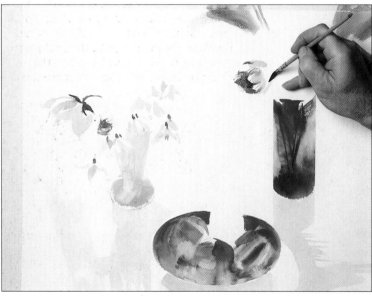

Stage 2
I like to keep the painting moving so I try to avoid dwelling in any particular area. This means I make sure that the bottom right and left-hand side of the painting are also worked out. It is at this early stage in the painting that I like to establish the contrast in tones between the delicate light flowers and the deep tones of the plums.

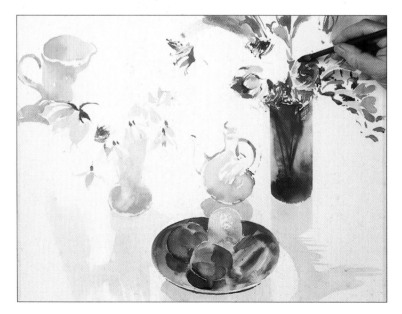

Stage 3
Using an Oriental brush I work up the anemones in the vase. The strokes here are a combination of full-bodied ones together with side-scraping dry brush ones. When painting flowers I like to establish all the bright colours first, before adding any foliage. This helps keep the colours clean and fresh.

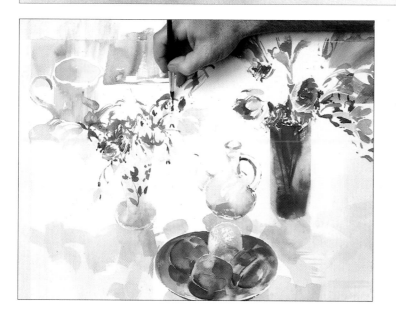

Stage 4

This is what I call my 'twiddly bits' phase where all the small marks, which you might term as details, are now added to provide a contrast to the heavier massed shapes. This gives the painting a certain movement. I have started to indicate here some of the background which will be needed to frame the top of the painting.

Plums with Anemones

I find finishing a composition always problematical. I have used deep colours in the background behind the anemones in order to counterbalance the weight of the plums at the bottom of the painting. There is contrast between the complexity on the left side of the painting and the tranquillity at the bottom. I call this balance – the interaction between calm and active areas.

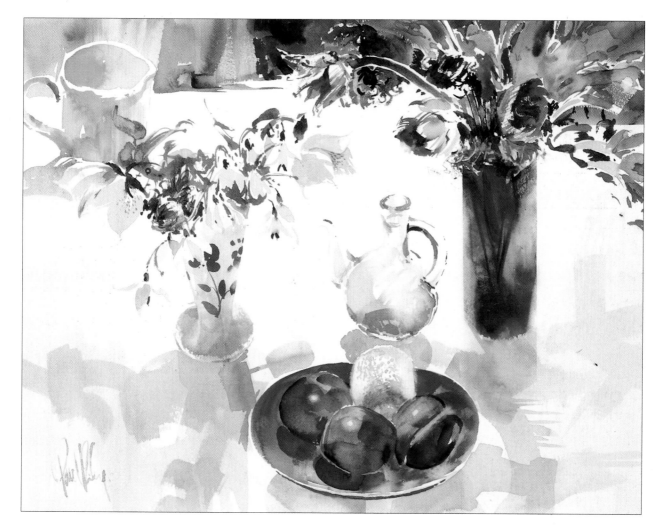

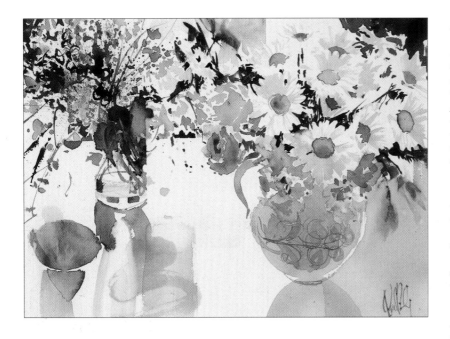

Daisies with Lemon

This is a 'contre-jour' ('against the light') composition, so the objects appear quite dark and have vertical shadows. I used these shadows to link elements within the composition. This painting is an amalgamation of big, soft shapes with many 'taschist' type strokes (particularly on the left-hand side) offset by careful painting around the daisies. The painting is unified by the predominant blue.

Bobemian Glass with Fruit

Here yellow predominates, offset by the touches of violet I used for the shadows and the glass. Focus on exactly what you see when painting glass, rather than what you think you see, so all the nuances in its reflective character can be captured. I have tried to establish a balance between hard and soft edges. The hard edges of the glass are counterbalanced with the soft outlines of the fruit.

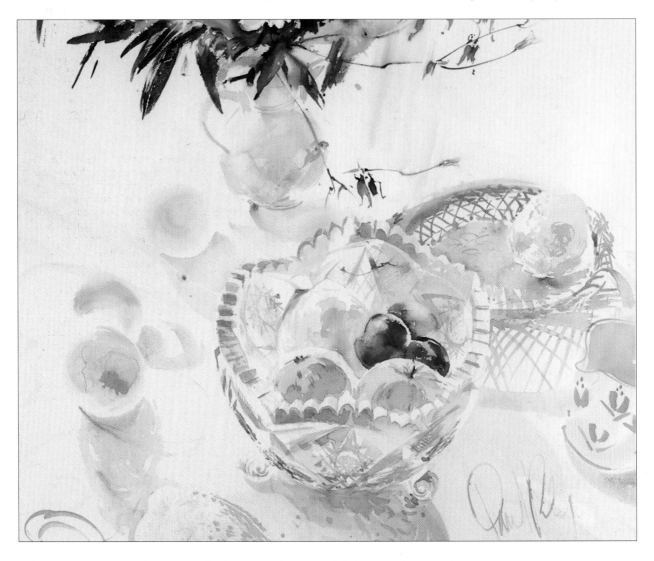

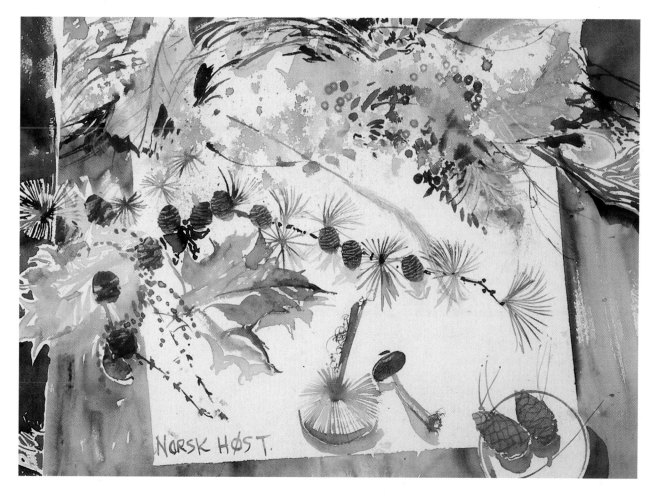

you have the disposition of three elements – the vases of flowers. These act as an opposition to the severity of the rectangle. One of the vases will be dominant and this will provide the centre of interest. So there you have it! Two basic geometric forms encompassing a central theme. It sounds simple but when confronted by several elements which have to be organised into some kind of order it is necessary to start with a basic plan.

A still life subject gives you an opportunity to play with many compositional devices since you are able to arrange and rearrange objects to fulfil your idea. Many people who use still life as a test-bed for compositional ideas tend to see all the objects as if arranged in a shopping basket. Each element is neatly contained by the rectangle of the picture. Another way to look at the subject is to imagine that the

whole group is part of a landscape. In this way you are able to see the potential in a much more dynamic arrangement of shapes. The reason is twofold. First is the fact that objects intersect the edges of the picture plane, which enables the edges to draw the viewer's eye toward the centre of interest. Second, it reduces the amount of so called 'background' area which is often the bane of the beginner's still life. I have also noted that this approach adds a certain explosive quality as the composition seems to reach beyond the parameters of the painting. This approach works best when you look down on the still life so that the collection of elements occupy most of your field of vision. (Your field of vision is the total arc of what you see without moving your head). I find that even if I am doing a painting of only a small vase of flowers, I will home in

Norsk Host

The predominant colour here is red. This reflects not only the time of the year, autumn, but also the fun I was having in the company of my Norwegian hosts. This is an example of a plan-view composition where I simply laid out a sheet of white paper and scattered the fruits of autumn around. Sometimes if you simply throw down a random selection of objects they compose themselves. A little shuffling around of the items can create white spaces to counterbalance the density of the objects. Variety and texture are also important in the composition. Small, round, circular shapes contrast with thin, spiky lines and the radiant shapes of the mushroom veins.

on a particular section, say cutting out three-quarters of the vase and cropping some of the flowers. This can then give you a 'bee like' view of the subject and enables you to work the flowers to a size where you can really explore their detail.

Before starting a painting I find it essential to have as strong an image as possible in my mind's eye. When I then come to my blank paper I know to a large extent what is going to appear there. Many people ask me how this is possible and does it not take away the element of chance and pleasure in the painting? My answer to the first question is that with a little planning it is eminently possible, and as to the second question the sheer process of painting always produces surprises so nothing is lost. With regard to planning you can indulge in more or less of it depending on the complexity of the subject matter. I find that a thumbnail sketch showing the bare bones of the design works well. If you include too much detail it is time-consuming and will tend to fog the main issues. The appearance of the sketch is akin to a map where I plot the main shapes as they interconnect, leaving no space unaccounted for. I also note the shapes between objects giving them as much resonance as possible. These sketches often have a spontaneity and freshness of their own so it is important that this is translated into the larger artwork. A form of proportional enlargement is then necessary to maintain this quality. My method for this is quite simple. I just divide the edges of my sketch into four and then place the sketch in the bottom left hand corner of my big sheet of paper. I project a line diagonally from bottom left to the top right corner of the sketch and then extend this line to intersect the farthermost edge of my large sheet. This will ensure that my painting will be the same proportion as the

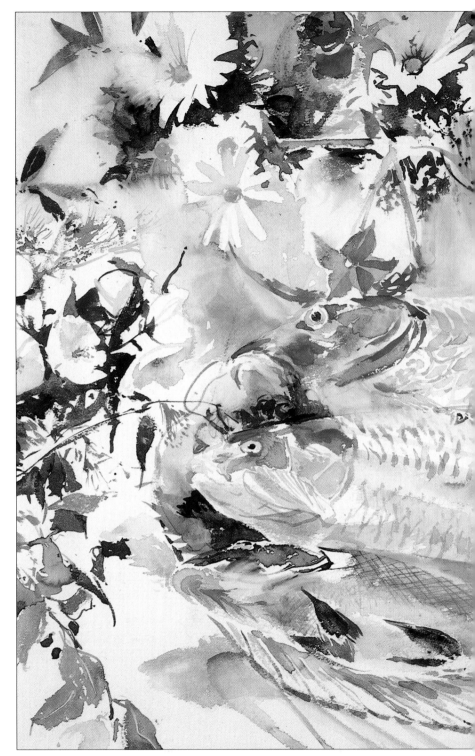

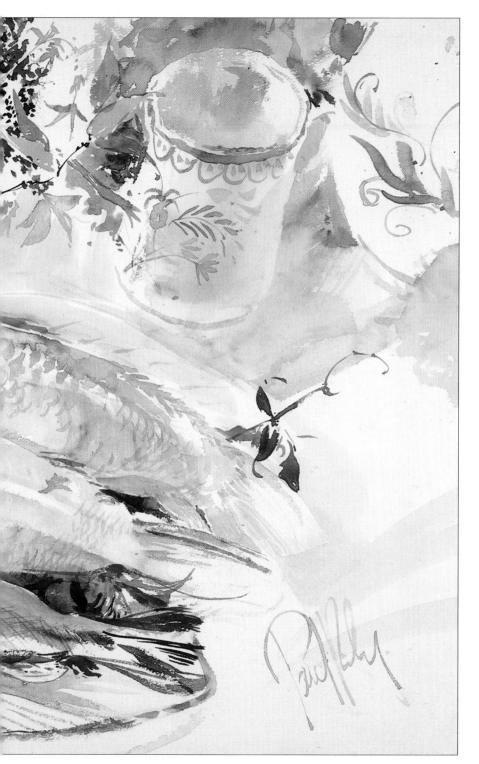

sketch. I cut off the surplus paper and mark the remaining edges in to four as in the sketch. This then gives me a grid into which I can plot the main framework of the painting using small dots of watercolour. This way I can visualise the whole painting before me.

Along with the basic plotting of the painting it helps to have some concept of the tonal relationships. The first thing that I decide on is if the painting is going to be close-toned, light or dark, or if it is to have strong tonal contrasts. The decision is based on subject matter. If, for example, the painting is about delicate, misty contrasts then the tonal transitions will be subtle and close-toned. However, it may be that you have very dark objects in conjunction with very light ones in which case the contrast will be quite dramatic. Always put the greatest contrasts in and around the main centre of interest. The reason for this is that strong darks against very light tones attract the eye, particularly if they have well defined edges. If you put these towards the edge of your painting the tendency is for the viewer's eye to be drawn away to the detriment of the painting as a whole. When I start a painting I quite often try to establish my darkest and lightest tones right away. This gives me my tonal range for the whole painting. The usual tendency in watercolour painting is to start light and then work towards darks. The drawback to this approach is that, as the painting progresses, you become more and more tentative about putting those strong darks in. In my preparatory sketches I quite often indicate these tonal ranges using charcoal or a soft pencil, say a 4B. Again I try to keep it simple in order to avoid fussy detail.

The next stage that requires a little forethought is the composing of colour. In the previous chapter I have referred to the many ways

Fish Dish

A friend gave me these three fish but they made a very uncompromising shape. My approach to painting them was based on a wraparound composition where the flowers and other items surrounded the dish. I then looked down on it and imagined the picture as more of a landscape, where the flowers were chopped off and not contained within the picture area. To increase the aerial feeling I used three-point perspective, which is most apparent in the slight angle to the mug on the right-hand side of the composition. This draws the viewer's eye towards the centre of interest.

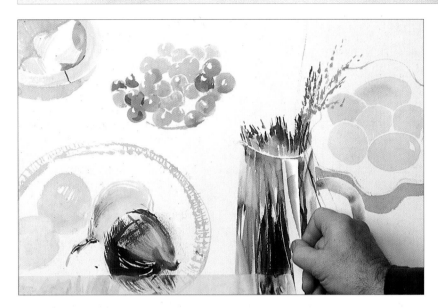

Stage 1

In contrast to my previous demonstration I have decided to use predominantly earth colours, with many of these mixed from the primaries. This composition is a game of two halves divided by the jug of dried grasses. When tackling something this complex, it is as well to be flexible in the use of tools. Here I am using folded paper, which has been dipped in paint, to produce the straight lines of the grasses.

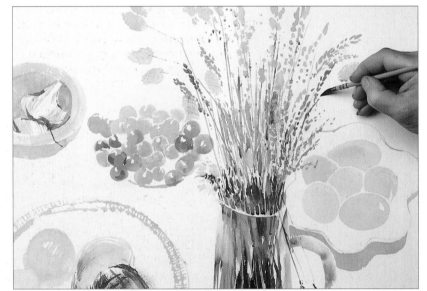

Stage 2

Having established the disposition of the main objects I now proceed to put in details of the grasses. It is at this stage that I also look for overlaps so that depth can be established.

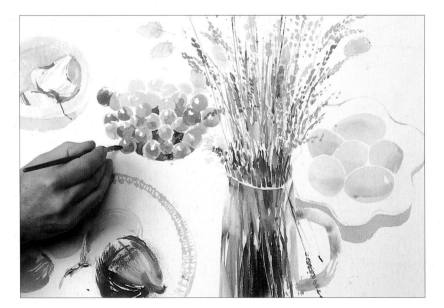

Stage 3

With the bulk of the under-painting done I can now start to build up tones through colour. I now have three dark areas – in the grasses, onion and grapes – which are offset by the two lighter areas of objects – the garlic and the eggs. I have to bear in mind that the grapes are further away than the onions and although I am putting in a substantial amount of detail I know that towards the end of the painting I will need to soften this area down.

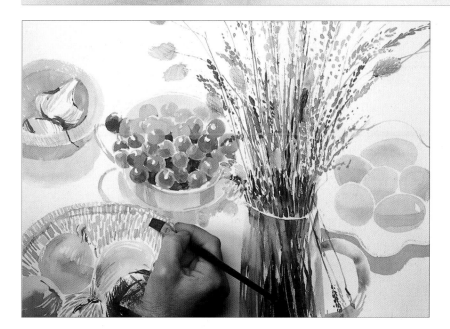

Stage 4

I am now putting in the detailed areas which increase the sense of reality. However, this is not just slavish detailing and I am very conscious of trying to produce rhythms in the strokes to add interest. Some softening with the sponge has been done to create depth, particularly between the dried grasses and the grapes.

Grasses with Grapes

To finish the painting I need to counterbalance the weight of the objects at the bottom end of the picture. To do this I turn the whole thing upside down and put in dark tones as background. Shadow areas are deepened where necessary, and some of the edges around the garlic bulb and grape bowl have been softened almost to extinction. Another device for increasing depth.

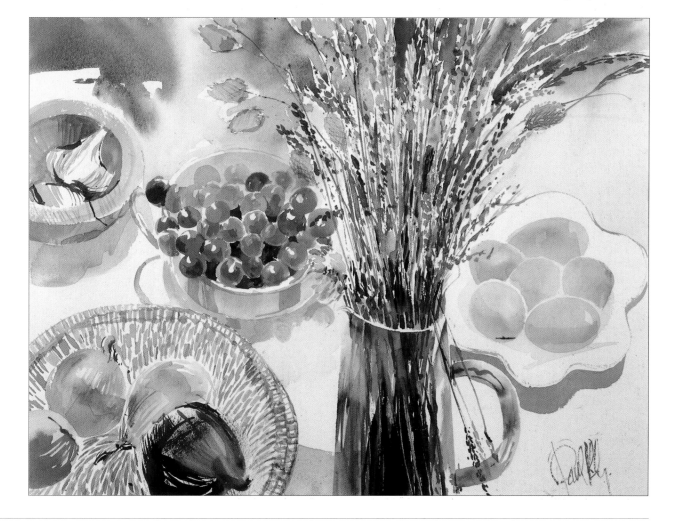

you can enhance your painting using certain colour combinations. In the planning of your picture, especially in the case of a still life subject, you have the possibility of arranging objects to suit a particular colour combination. Whilst you are at the planning stage you might like to consider the impact of your selection. This can be done by using small touches of the chosen colours and indicating their location on your sketch. The word often used when trying to achieve a balanced colour relationship is 'harmony'. Its purpose is to signify that all the colours chosen have an interrelationship which pulls together the whole painting. One way of achieving this is to ensure that each basic colour that is chosen is triangulated. What do I mean by this? Say, for example, there is a bright red object in the upper-right of a painting then my instinct is to look to the lower- and upper-left to see if I can find some other red to act as a counterbalance. The other colour may be very slight but finding it is the way to ensure that the red does not stand out like a sore thumb. Finding three objects of similar colour is what I mean by triangulation. The same goes for all of the other colours in the painting. This is not a hard and fast rule, it is only in order for you to think about colour and its placement. It will also increase the possibility of introducing that elusive 'harmony'. Remember that colour is very much a question of your personal preferences. What may excite you may not necessarily excite others. Do not despair, this is normal. You may rest assured that there are many out there who will strive to see what it is that interests you and, who knows, you may even alter their tastes accordingly. I have always maintained that if you are starting in painting it is best to experiment with many different colour schemes if only to be

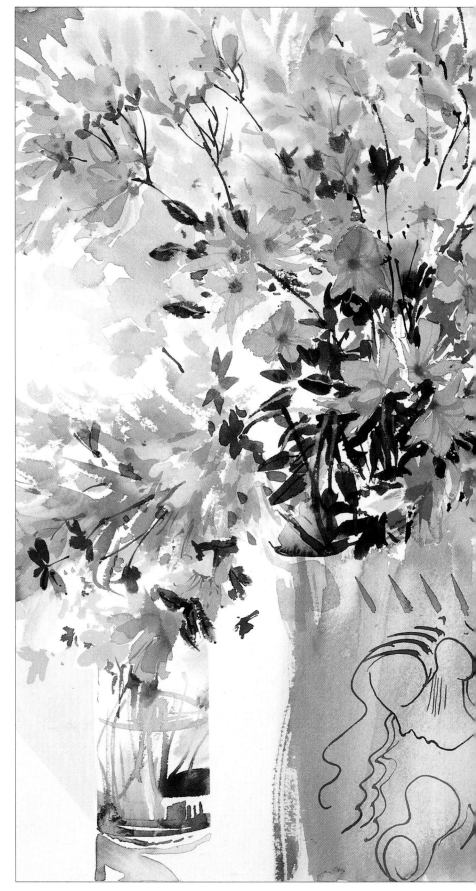

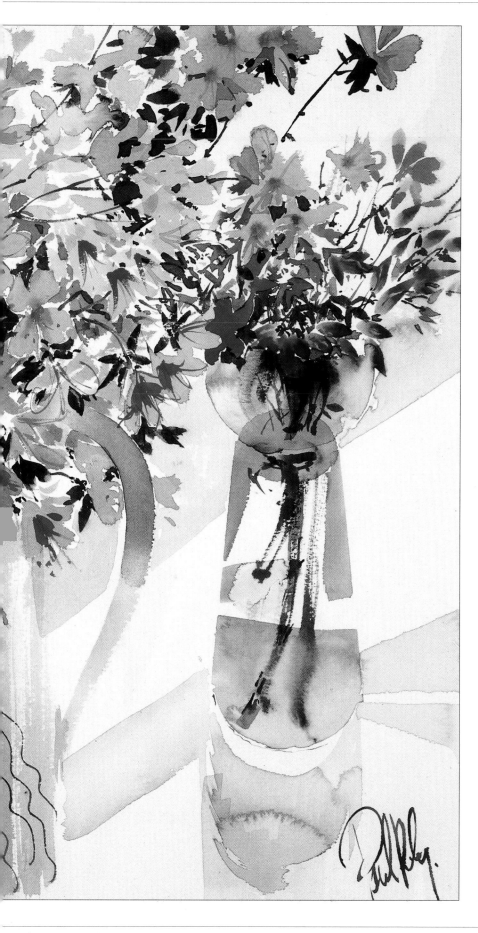

Jug of Azaleas
In order to capture the explosive feel of the azaleas I have very closely cropped the view. It is not always necessary to show an entire container of flowers. The vase is treated in a very abstract way and the light is creeping around the form. The spaces either side of the jug are occupied by more abstract glass containers. Much can be implied without putting in all the detail, a reinforcement of the old saying 'less is more'.

exposed to new possibilities. I also advocate this for jaded professionals who can so easily get stuck in the rut of tried and tested methods. One way of doing this is similar to Claude Monet's technique. Try to paint a particular subject using different colour ranges. By this means you will come across quite unexpected results – results that can even set you off on a track like Picasso during his blue period.

You may have noted that I have tended to deal with the business of composition in the abstract, using terms like line, edge, colour, tone and so on. This is because these are the building blocks which help define the objects around us. A teapot, for example, has cyclic curves, and its colour is divided into tone. All of this has to be counterbalanced by other edges, tones and colours provided by other objects. This is the game that painters play before they get to the stage of deciding the 'why' of everything, a subject I shall deal with in a later chapter. Suffice to say that composition, design or balance, call it what you will, is one of those mysteries that will intrigue painters forever. Note how other painters in the past have tackled this aspect using the pointers that I have indicated.

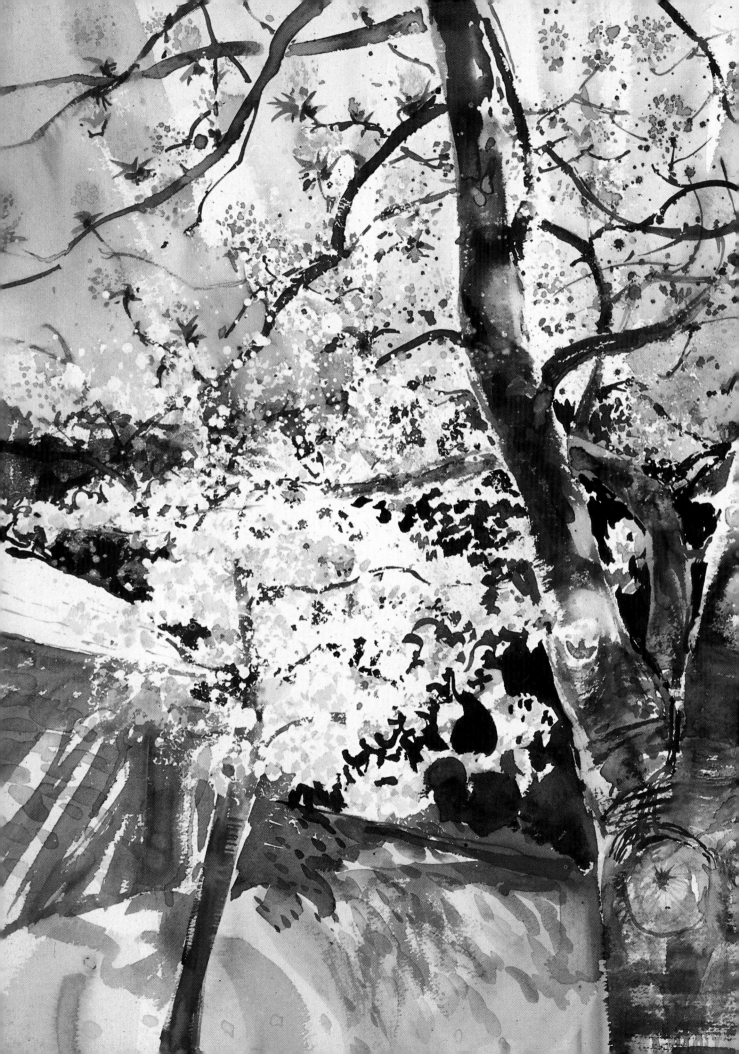

CHAPTER 4

ATMOSPHERE

We are all sensitive to atmosphere. When we look around ourselves we are often amazed at the variety in the landscape. Few of us are unmoved by the phenomenon of the sunset; an amalgam of colour and light that transforms even the most drab of surroundings. It is the painter's wish to imbue their work with some of the mystery and atmosphere that a contemplation of the landscape evokes. In this chapter I want to show what lies behind the obvious elements of skies, trees and water, for which purpose watercolour is so well suited to render those illusive qualities of light and dissolved form. Nature has a special way of displaying her secrets. Let us see if we can express them.

even reflects your own mood. This can be a bonus, although the weather and its antics can break your mood and you may have to fight to cope but this in itself brings about a special kind of exhilaration if you succeed. I recall that on one occasion on the Indonesian island of Bali the overwhelming circumstance was heat! The viewpoint I had chosen was out in the blazing sun. Swathed in every kind of cloth that I could lay my hands on, I battled on to the point where my brain fried but I got what I wanted – a painting suffused with the heat of the day.

One of my methods for setting the mood, and thereby the atmosphere, is to apply an underwash. The wash is most easily applied with the board holding the paper at a slight incline. Then, using a well-loaded brush, draw the paint down in a series of horizontal strokes, slowly picking up the previous wet edge. It is important not to let the wash dry until you have completed it so it is essential that you have mixed a generous quantity of paint before you start. Allow the wash to dry and resist the temptation to fiddle with it. When it is dry you can always do any repair work with a soft sponge. You may have a white object you wish to leave out whilst laying the wash so delineate (or even mask) this carefully before you begin.

With a wet wash I generally spray the paper first using a small hand spray. Alternatively I brush over the paper with clean water. I then proceed to brush, flick or splatter colour until I have achieved the random look that I want. Once again, if I need any white areas I can mask them out

River Pontoon
The particular atmosphere I wished to create in this painting was daybreak. This large body of water reflects soft, misty lighting that is absolutely perfect for the watercolourist. In order to establish the feeling I wanted I laid an underwash of soft grey blues. This underwash was predominantly stains – phthalo blue, mauve and a little ultramarine. The underwash has a unifying effect that controls all the colours laid on top.

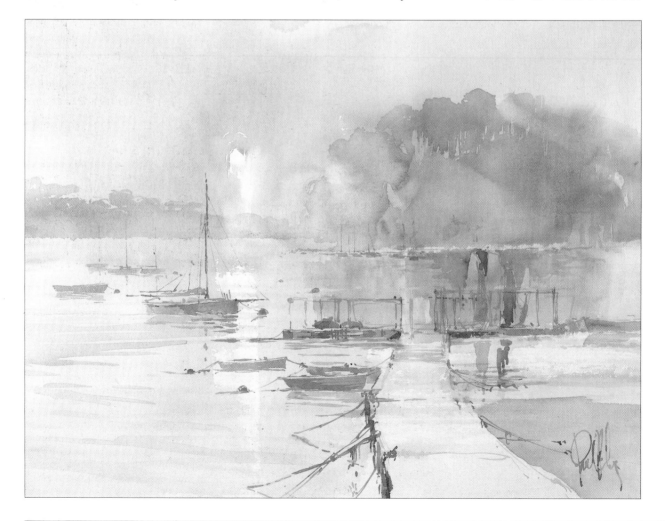

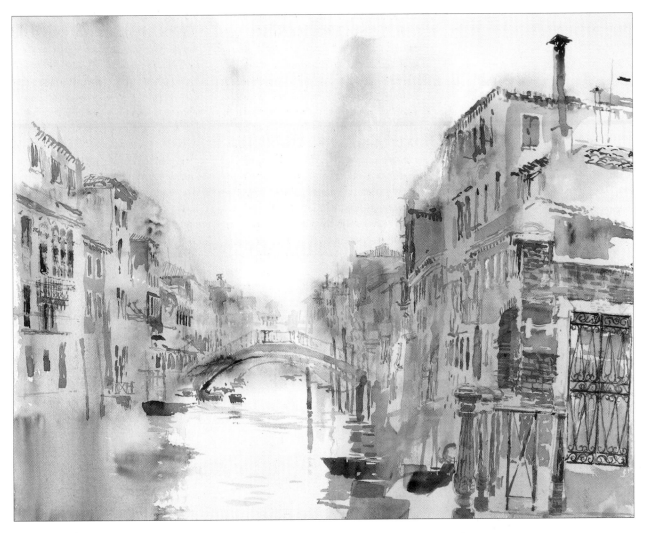

using tape or masking fluid, or blot them out and define them a later stage. The pigments that I use are normally of the staining variety to ensure that they will not move during subsequent overpainting.

You do have the opportunity to exploit the wetness of the underwash by putting in veils of darker tones which can suggest clouds, trees or mountains with soft edges. You will note that the wetter the wash the softer the edge. As the wash dries the edges become progressively crisper and in this way you can suggest depth in your painting. The softer the edge the further away an object will appear.

Another use for the wet underwash is when expressing cloud formations. For this you really need to look at clouds to note their variety. Many people tend to see them as small white fluffy balls that are evenly distributed. In fact they vary in many ways, from wispy veils to small dotted clumps and great rolling billows. These differences in form have their various names – cumulus, cirrus, cumulonimbus and so on. These are names that you do not necessarily need to know but it may help when it comes to identifying and understanding these most extraordinary forms. The technique for painting them is to employ various blotting methods using soft tissue paper, soft rags, a natural sponge and a moist brush. Very small trailing clouds or dotted versions can be lifted using a small twist of tissue.

When choosing colours for

Canale de' Girolamo
Because of the amount of depth in this painting the underwash was worked on whilst still wet. This gave soft, hazy effects both in the water and in the nature of the distant buildings. As the wash dried I advanced towards the foreground, putting in more detail which still blurred, but was somewhat crisper. Final details were added in the foreground when the paint was completely dry.

Norwegian Landscape

Norwegian fjords are a particularly awesome sight with soaring mountains rising straight from the sea. These create a special atmosphere of their own where clouds drift amongst the peaks. The small villages are invariably built on flat land at the base of these hills. The buildings stand out with their red walls and create an interesting counterpoint to the greenery of the surrounding landscape. I have tried to show the verticality of these mountains and the way in which the sky is torn up by the peaks. A lot of splattering and detailing was necessary to create the solidity of the rock.

underwashing you need to bear in mind the mood that you wish to portray. Generally speaking landscapes have a preponderance of greens and blues and the safest option is a variety of blues. For this I use staining cerulean blue, (with a phthalocyamine base), a phthalo blue, (which is much darker), and mauve (to give reddish tones). Having said that, other colours allow you to create quite specific atmospheres. For example, I use light reds which veer to orange (such as permanent rose and raw sienna) to generate a misty, dusk-like feeling. When painting in Venice I also noticed a special light that was quite greenish and for this I used a mixture of phthalo green and lemon yellow. It is well worth your experimenting with different

colour combinations to not only see what happens but to try the shock of the new!

The one thing to bear in mind is the consequence of putting certain colours over underwashes. Watercolour is a transparent medium and consequently one colour placed over another will result in a third colour. An example of this is when you paint a yellow red (like cadmium) over a yellow blue (like phthalo) you will not get violet but brown, a tertiary colour (see Chapter 2), so choose your colours very carefully.

Another way to create atmosphere is to employ an overwash. This is a device that can serve two purposes – one is the creation of a mood or atmosphere, and the other to help unify the painting.

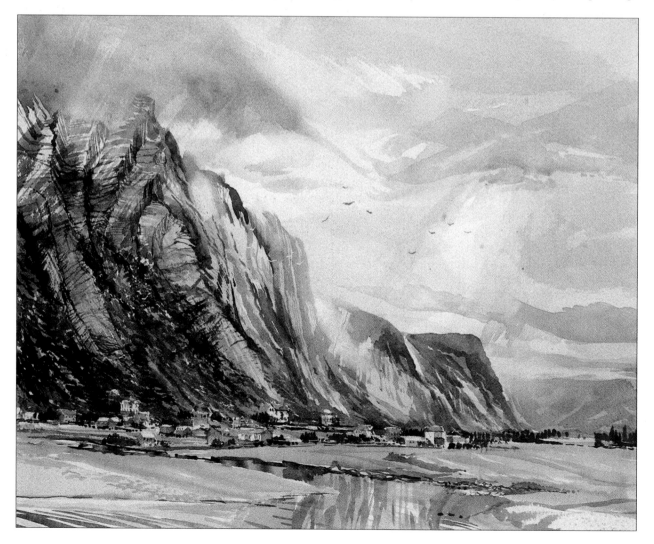

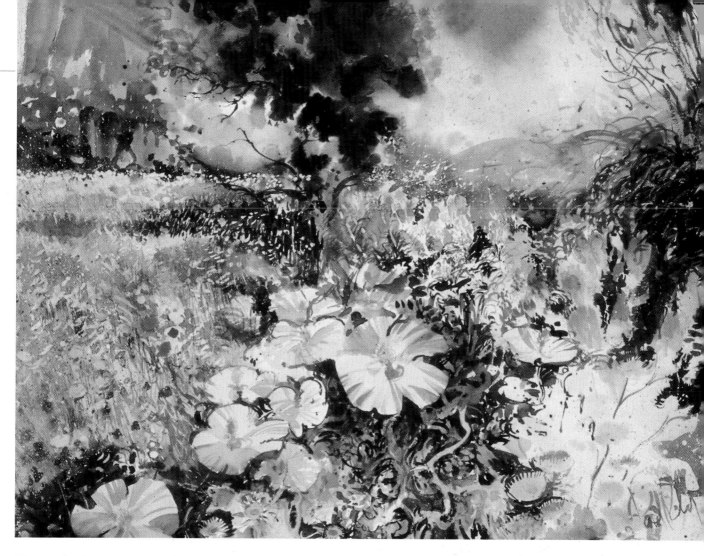

The method is to wait until your entire painting is bone dry. You then mix a quantity of thin colour. This colour will depend upon the effect you are after. Determine whether the wash is to cover your painting entirely or only in part, and then go for it! A pale blue is very effective and will help to calm down a painting that may be too busy with a myriad of different colours. I must admit that it takes a bit of courage to take a large brush full of colour and slosh it all over your carefully executed work but once you have tried it you will be surprised by the effects.

WATERSCAPES

It seems that watercolour painting was almost invented for waterscapes. Many of the peculiarities of water can be best expressed by this medium. Ripples, waves, scattered light and reflections are easily rendered. Like all aspects of watercolour painting the secret lies in sequences – what to do first, second and third. One of the tricky things about water is its illusive colour. Being a shiny medium water always reflects everything that surrounds it and, being transparent, you can see through it. When I look at water I also look at what is above it and what is in front and behind me.

If you imagine the hump of a wave, the side that is furthest from you will reflect colour in the distance. The top of the wave will reflect the sky whilst the slope facing you will mirror the colours behind you. This crudely means that each wave has approximately three colours. The sequence is to lay a light wash of the sky colour so that you follow the colours vertically one above the other. This may sound complicated but what it means is that you are basically

Chios Poppies
The atmosphere I wanted to create was one of intense heat and the plethora of flora. This small corner of a wild flower field in Greece was the perfect opportunity for experimenting with successive layers of masking fluid. Pale colours were laid first and then masked to produce the smaller, lightest flowers. Further masking was laid with an overwash of brighter and deeper colour, and so on until about four or five layers had been painted. The main poppies were 'negative' painted at the outset, and then colour was put in against the texture to make them stand out.

Stage 1

When starting a complicated subject it is usually necessary to draw some basic indication as to where things will be. To do this I use a very fine-tipped round sable with very pale-blue pigment, usually a stain like phthalo blue. Although faint in this photograph, it is intended to show how light it needs to be so that the line work does not show up in the finished painting.

Stage 2

The sky has been very loosely washed-in using a large hake. This colour is taken down through the painting to include the foreground area. This stops any uncomfortable junction between sky and land. Clouds are blotted out using soft tissue. Note that the drawing-in is still just readable.

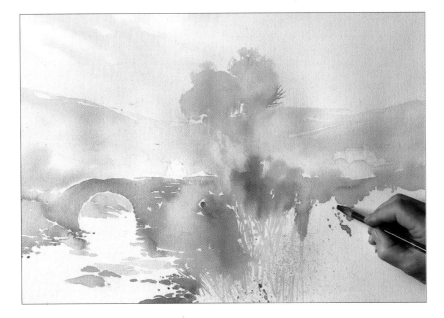

Stage 3

Now is the time to establish some of the darker tones. For this I use an Oriental brush with which I can side-scrape as well as insert fine detail with the tip. In order to keep some of the edges soft I re-wet some of the areas, notably the background and around the tree. Colour is then dropped in creating a misty atmosphere.

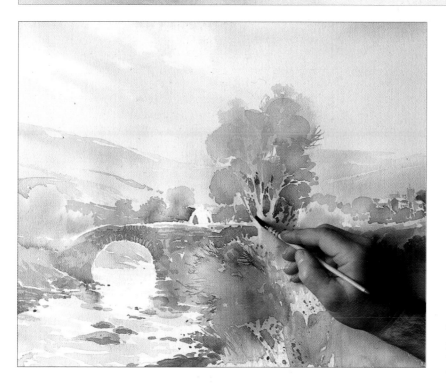

Stage 4
One of the more interesting ways of using watercolour is to 'negative' paint certain shapes. To do this the branches have been left light and I am painting the foliage that is seen between them. This also gives me the opportunity to include a small figure on the bridge. Texture has been added by both splattering and overpainting.

Dartmoor Bridge
To complete the painting I introduce some atmospheric touches. One method I use is to employ a sponge to both wipe and soften edges. This can be seen quite clearly under the bridge and in the foliage on the right.

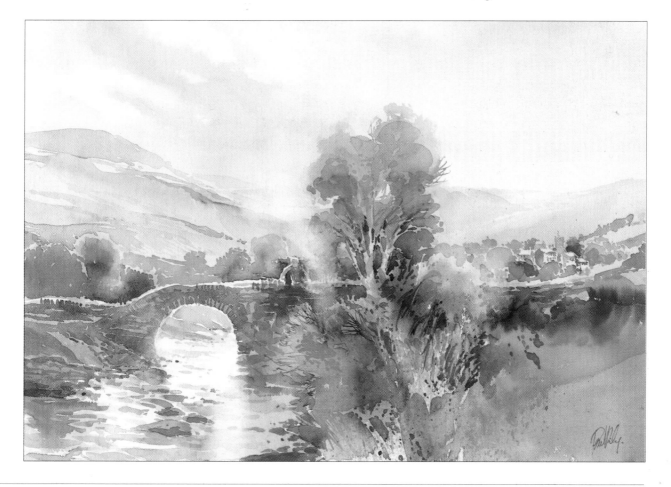

painting the sky again upside down! This is best done when the paper is still reasonably wet. Once this wash is completely dry the next sequence is to paint the ripples that reflect the colours behind you. These could be the green of the trees or the colour of the sand, for example. Finally, the colours in front which can be anything from reflections of boats, the sky colour beyond, the colour of headlands and so on. These colours tend to 'wander' in and around the wavelets.

The main issue when painting water is its reflective quality. The fundamental point is that a reflection is a vertically projected image of what is above. If the water is absolutely still, like a mirror, then the reflection will be an exact mirror image. Alternatively, if the water surface is broken by wavelets then the reflection is extended. In other words, perspective comes into play. What happens is that as the wavelets approach they increase in size which results in an increased projection of the reflected image.

When the water is completely ruffled the reflection is confined to a small area adjacent to the object, be it a boat or the shoreline. The important thing to consider when looking at water is to be objective. Try to analyse what is going on. One of the most significant elements that changes the character of water is the wind. Sailors are well aware of this and use it to navigate their boats. A painter needs to be able to depict these changes in a convincing way. When painting distant effects all that is required are subtle changes of tone. As the waves come

Isle sur la Sourge at Night
Nightscapes offer a wonderful opportunity to explore atmosphere. It is best to position yourself near a reasonable light source in order to see what you are doing. Here I was able to indulge in very dark tones but still allow portions of the paper to show through as light reflections. In an opposite manner to underwashing this painting has been overwashed with various blues to lower the tones even further.

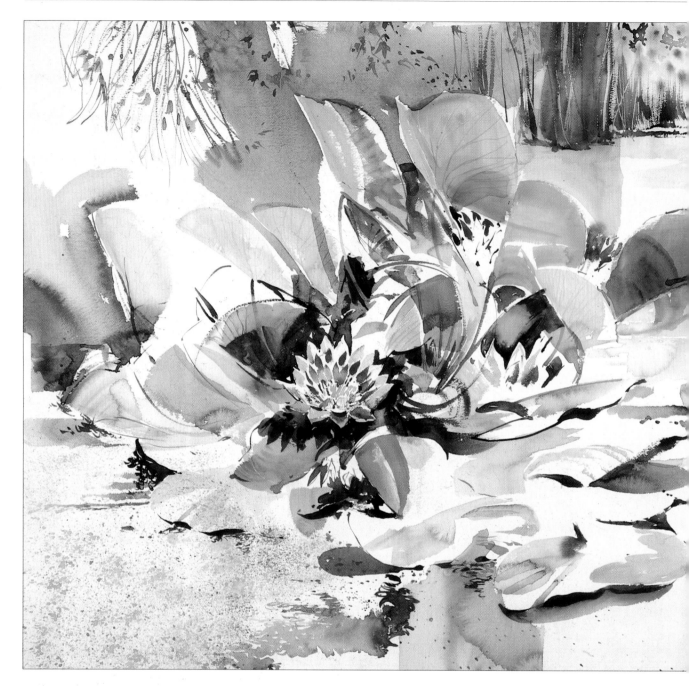

Lilies, Devon
*Here I have abstracted my subject even
further to create yet another kind of
atmosphere. I have simplified the leaf
shapes into soft folds. The only vivid
areas are the flowers. To do this I have
divided the picture plane into three
zones – background, middle-distance and
foreground. To render some of the shapes
you need to simply dwell on the area
that interests you without necessarily
attempting to be too realistic.*

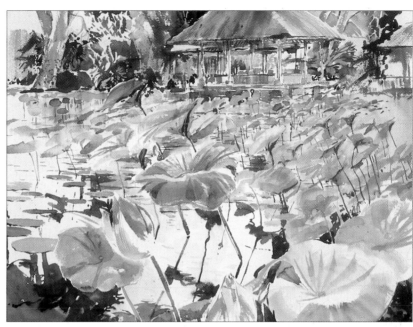

Lily pool, Ubud
Lily ponds have always presented an attractive opportunity for painters. The problem is they are quite difficult to paint. It is worthwhile attempting to paint them at various times of day and from different viewpoints in order to understand them better. This painting was done near the middle of the day when the leaves were reaching for the sun.

Lilies in Palace Pool
These lilies were especially annoying as they would only open when the sun was shining. If a cloud passed over they would promptly shut. A very pale underwash was laid leaving only the area behind the white lilies. I treated the whole thing in a very abstract manner to help reinforce the delicacy of the lily stems. Experimenting with different ways of seeing the subject helps develop an understanding of it.

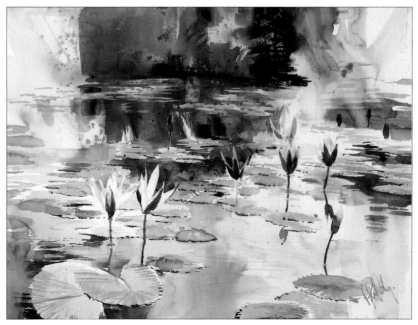

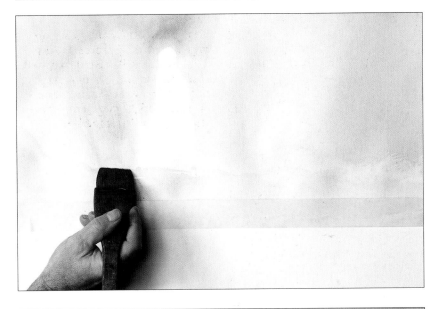

Stage 1
Waterscapes always need careful planning. I use a very fine broken blue line to simply indicate the horizon. I then fix the position of the boat which will be shown by only two dots – top and bottom – to locate it. To ensure a dead straight line at the junction of water and land I use a low-tack masking tape.

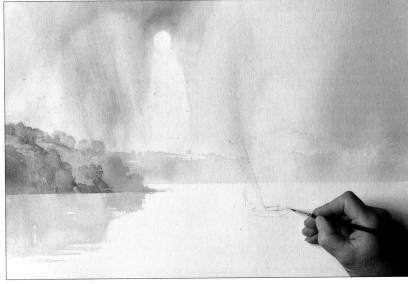

Stage 2
A fair amount of the background is now completed. The sky is first washed in leaving a dry area for the sun. Colour is then flooded over the sky and through the water. Working from the far distance I apply the colour whilst the background is slightly damp. As each plane comes nearer I work on the paper as it dries. The reflections in the water on the left-hand side are put in when the paint is completely dry.

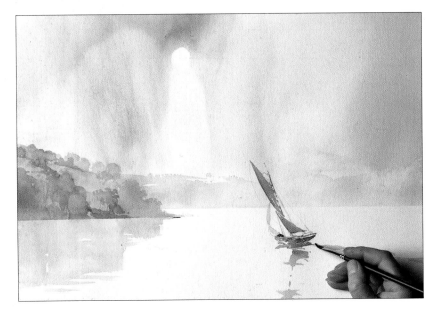

Stage 3
I now develop the focal point, which is the small gaff-rigged yacht. It is necessary to keep it fairly simple, with the minimum amount of detail to make it appear convincing. The reflection is worked vertically below the boat, picking up its colour. If you are not confident with drawing boats use a photographic reference from a yachting magazine or book.

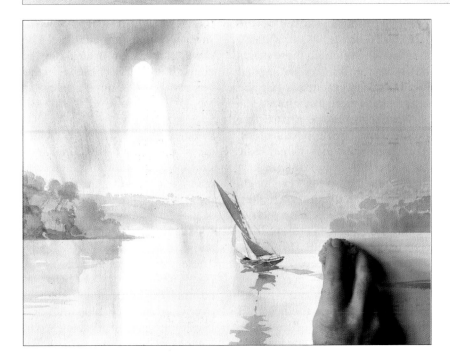

Stage 4

To provide atmosphere I am now wiping with a soft sponge. This suggests the reflective quality of the sun. Further softening is applied to the far distance. The sponge work helps to emphasise the crisp quality of the boat.

Solo Sailing

The feeling of atmosphere has been established. What are now needed are the final touches to indicate the flatness of the water and its tranquillity. I use a one-stroke brush with the palest of tones. The watchword in all this is to keep it simple.

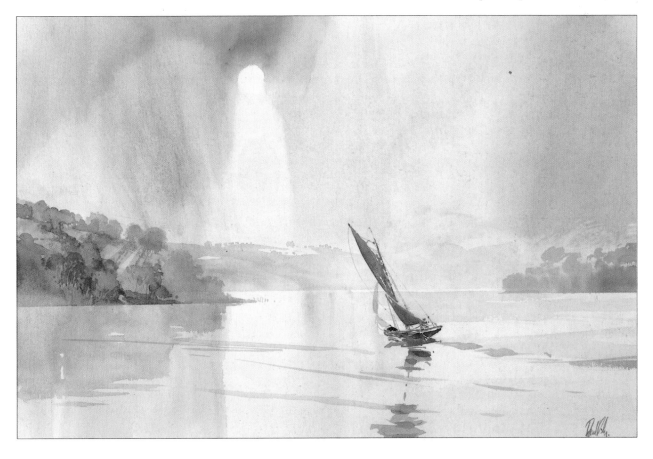

This technique combined with reflections and ripples will convey much of the magic of a riverscape. Further sparkle can be added by using a scalpel or similar knife to pick out bits of the paper. You can combine this with scraping to produce horizontal white streaks. This method works well when applied to dark areas in the water, such as reflections from trees.

Waterscapes offer boundless opportunity for the watercolourist to experiment, but do not be disappointed if your first efforts do not come up to scratch. Persevere and you will be rewarded. Being beside a body of water trying to unravel its mysteries is especially satisfying in itself.

Riverside Village
When attempting such a complex subject as this it is as well to use a particular atmospheric colour to unify the whole. This is to overcome what might otherwise be an overly oppressive green painting. To counteract this I have looked for other colours, hence the violet blues and golds with yellow fields surrounded by blue and violet skies.

CHAPTER 5

CHARACTER

We think we know each other, but do we? I am not talking of our inner selves but the way we appear. Although we may perhaps continuously study one another we tend to be over familiar with what we think we see. For example, most people when they first draw a face tend to put the eyes near the top of the head because they are the dominant feature. In fact they are really positioned nearer the centre of the head. So, we need to examine our subject as never before and see with a 'clear eye' so that the sitter's character can manifest itself. In this chapter we will analyse our subjects, first through the understanding of proportion, then through the search for that illusive self.

PORTRAITS AND LIFE PAINTING

My mother is the portrait painter in our family. It is she who points out the subtleties of flesh tones and colours. She also infuses her own work with a romantic touch, which in some ways I have inherited. I tend to believe that depicting the human form in merciless realism results in a less than satisfying and rather unappetising image. I also believe that it is the artist's role to show an aspect of the sitter that not only reflects their personality but also their mood.

The special nature of portrait painting, against photography, is that the artist can combine many aspects of the sitter's character – from fleeting eye movements to the small quirks of expression around the lips. A photograph only records a look at a split second in time, which to my mind is only a fraction of the real persona. Copies from photographs invariably have a certain lifelessness, so why deny yourself the congenial company of a sitter with whom you can converse on a range of topics?

If you wish to try portraiture there are three aspects to bear in mind – *proportion* (which is at the heart of all drawing), *centre of interest* (see Chapter 3) and *colour*. I shall deal with each of these core subjects in turn.

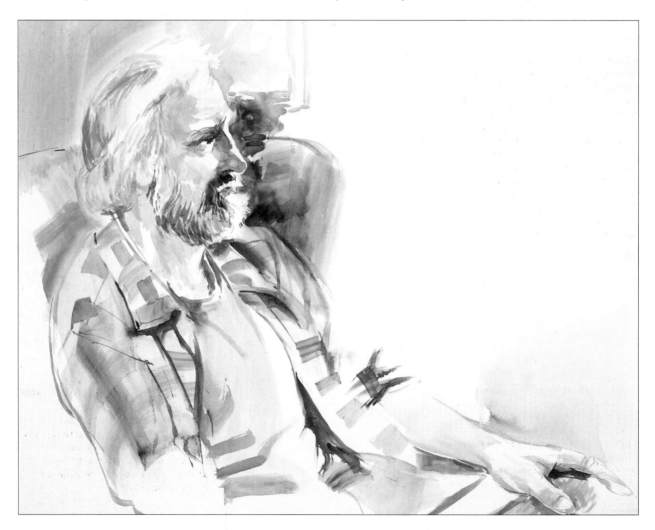

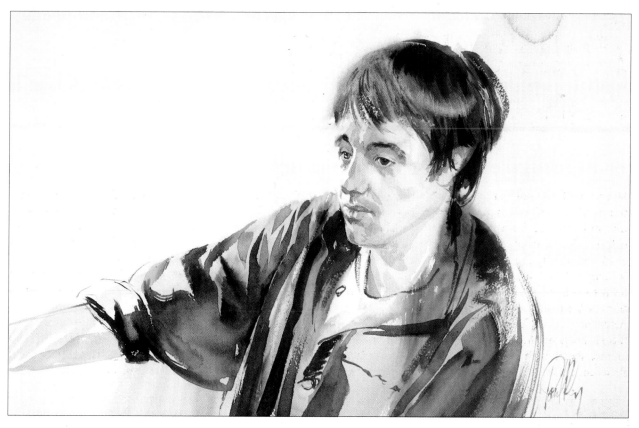

Milan

More often than not portraits are painted in a vertical format. However, I often try to experiment with a landscape format to create different shapes. In this portrait I established a high viewpoint in order to give more drama. The flesh colour was overpainted at the later stages by simple overwashes, which also incorporated much of the background colour. The sheen on the hair was achieved by wiping with a soft sponge.

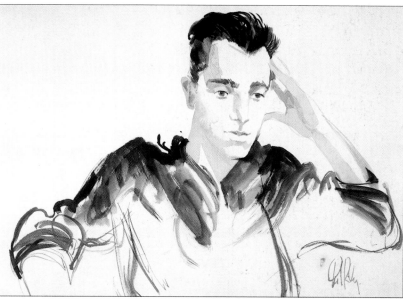

John

My dear friend John is an extremely workmanlike character. He is in fact a jeweller which is why I included his hand in the painting. I have used a fair amount of background tone to highlight the lightness of his hair and beard and to emphasise his strong, characterful features. When painting somebody with a beard you must be careful to avoid caricature.

Mark

To make this rapid and seemingly spontaneous sketch I used a smooth Hot Pressed paper. The brush I employed was a combination Oriental style brush with a responsive wolf hair tip. To begin I painted the eyes and worked outwards. The inclusion of the hand has added to the meditative pose.

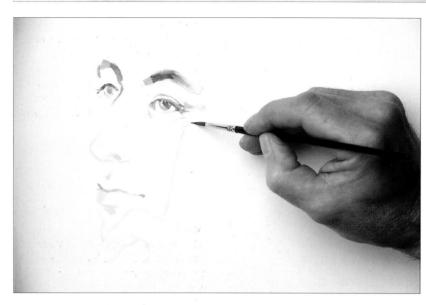

Stage 1

With most portraits I tend to start with the eyes. I always maintain that if you get these wrong at the outset then you may as well stop and start again. Once the eyes have been virtually completed I then work the underside of the nose and lightly indicate the mouth.

Stage 2

Because the hand is supporting the head it needs to be put in and the scale adjusted to suit the head. This in turn poses an added complication that provides a real challenge. The interesting thing is the way in which the hand slightly distorts the face. I have to be careful in order not to let this look too grotesque.

Stage 3

Now I know where the hand is situated I can block in the body and some of the background tone. This colour helps to reveal the shape of the arm and the back of the head. When working on the clothing I have found it best to paint with as large a brush as possible, something like a hake.

Stage 4

I now build up deeper tones in and around the figure using a hake. Additional colour has been brought into the face by way of an underwash, again using a hake. The hair has been lightly indicated with a soft edge.

Mark

The finishing stages are invariably details only, for example around the arm, watch, neckline and hair. The hair is painted with a rich mixture of earth colours, burnt sienna and a phthalo blue stain. Highlights are scraped out using a penknife. Additional background washes drawn over the face add all of the necessary colour.

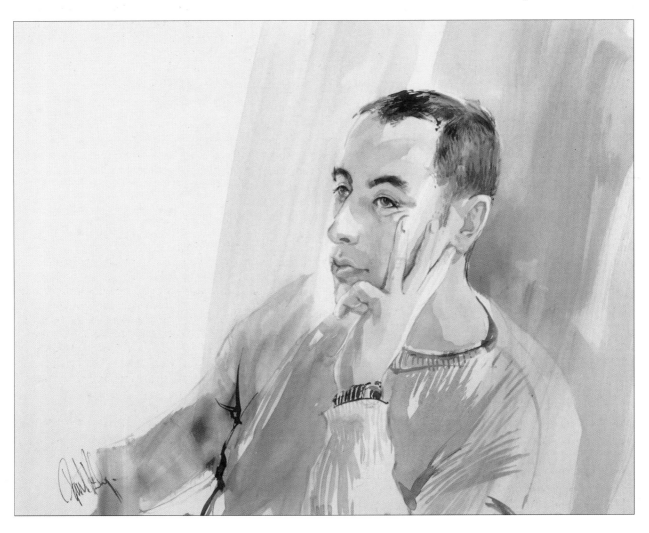

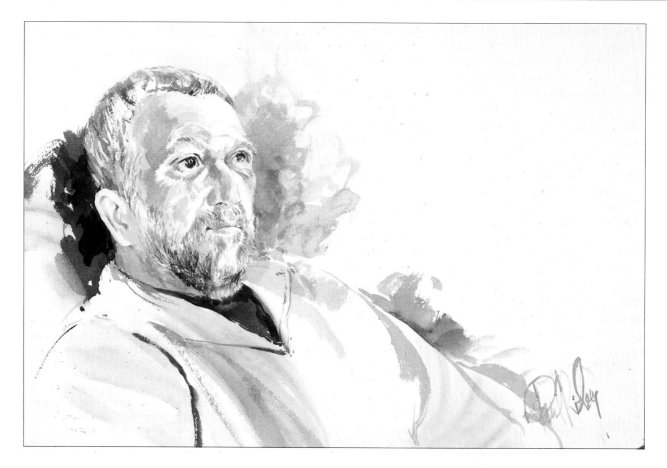

PROPORTION

Most people are immediately attracted to the eyes. Unfortunately, because of their prominence, most beginners and children tend to place them in the middle of the forehead. This leaves the sitter with little or no room for a brain! A basic rule of proportion is to place the eyes midway between the top of the head and the chin, with the mouth half way between the underside of the nose and the chin. This is a generalisation that subtly changes between individuals but it gives you a simple framework. Obviously these proportions change if you are looking up or down. If you are looking up you will see more chin and less forehead, looking down it is vice versa. The top of the ear is approximately in line with the eyebrows, and the lobe with the tip of the nose.

The neck is supported by muscles that come from behind the ears. Many painters make the neck too narrow. In a full-face portrait the height of the face from chin to top of head is approximately one-and-a-half times the width of the face. In profile the height of the head is roughly the same as from the tip of the nose to the back of the head excluding hair. I say 'approximately' because variations occur that will show up when careful measurements are taken, which is something most good portraitists do.

CENTRE OF INTEREST

The eyes are generally the main focus of attention in a portrait. It is in these that the greatest tonal contrast occurs. However, concentrating on both eyes at once creates a dichotomy. Therefore it is preferable to concentrate on one of them, as this will give more dynamism to the pose. This device was wonderfully exploited in

Patrick
Periodically I find a model whose physiognomy is worth exploring. Patrick is a large man with a lot of character and he looks different from every angle. In order to understand all his features I made a very careful study. All the planes in the face have been built up using very thin successive layers. In contrast to this I have treated the clothing and background in a very broad and brusque way.

Rembrandt's brilliant portraits. The other thing to note is the direction in which the eyes are looking. If a portrait is to be full face with the eyes looking directly at the viewer then the head can be placed more or less centrally in the painting. If, however, the eyes are looking left or right in either profile or three-quarter view, then give the eyes and head some space to look into. If looking to the right then place the head more to the left. The same applies if looking up or down. One of my personal idiosyncrasies is to include hands in a portrait. This inclusion gives rise to a kind of dialogue between hands and face and is a strong indicator of the sitter's character.

COLOUR

The following should help prevent muddy or garish interpretations. The first thing I avoid is semi-opaque or precipitating (granulating) colours (see Chapter 2). Unless you are painting a portrait of a coal miner these pigments will unduly 'age' the face and will cause problems with delicate tonal gradations. I prefer to use stains (check with the paint manufacturer's specifications). Lemon yellow, permanent rose, and cerulean blue are my usual choices. When these are combined they produce a tertiary flesh colour that can be easily modified towards the red, yellow or blue scale.

My first stage in laying a flesh tone is to paint the whole face with a mixture of these colours. I allow the variations of red, blue and yellow shades to run into one another – lighter areas are slightly more yellow, red on the cheeks and blue under the chin, for example. I wait for the paint to dry thoroughly and I then use a soft sponge to lift any highlights. Again,

Patrick's Profile
In line with my liking for introducing hands into portraits I have done this with Patrick's Profile. In comparison with the other painting a different side to his character has been revealed. It is only by repeatedly painting a sitter and conversing with them that you begin to unravel the personality behind the image.

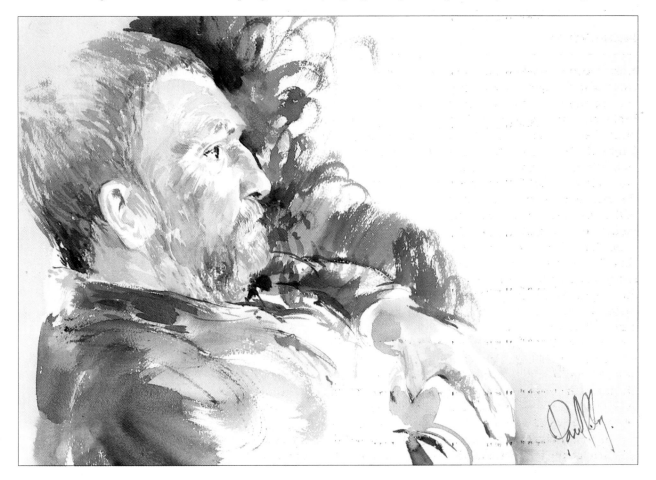

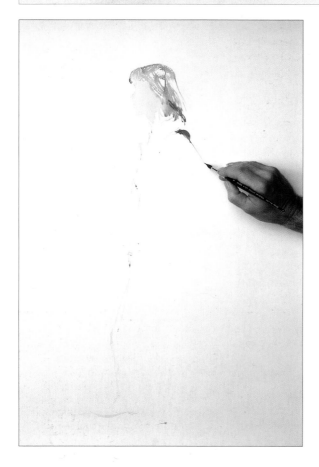

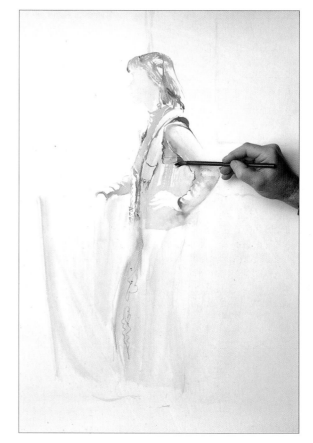

Stage 1

With a standing figure it is important to get the proportions correct. To do this I have to determine the size of the head on the paper and then, using this as a scale of measurement, decide where the feet are likely to be.

Stage 2

In the second stage you can see I am using a sponge to erase any mistakes. In this case, a certain angle in the pose. I have used a traceur combination sable and squirrel hair to add fluidity to the folds in the costume.

Stage 3

As in any painting, I like to establish some very dark tones at an early stage to give me a complete tonal range for the picture. Here you can see certain of the deep shadow points have been put in, for example, under the arm. The farther arm is lightly indicated for depth.

Stage 4

The model is wearing a very bright costume. This gives opportunities for strong colour and pattern. I have started to indicate much of the detail, leaving the final touches to hands and face till last. For the costume work I use the big brush approach which then contrasts with the delicate work around the face and hands.

Sarah

The completion of the picture requires some indication of the background. This is to give the model a location. I have deliberately kept it simple so the eye can dwell on the colour and poise of the model. Note that I have introduced some darker tones around the feet – this is negative painting.

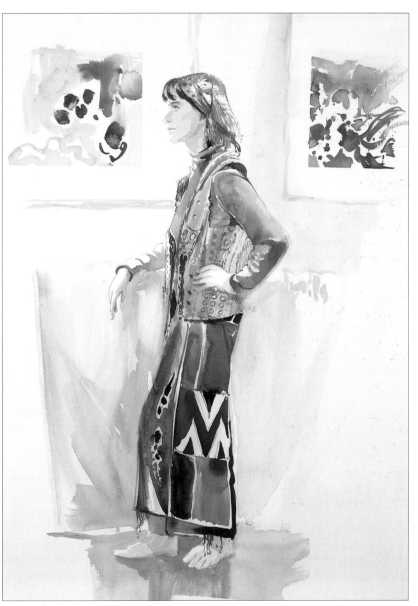

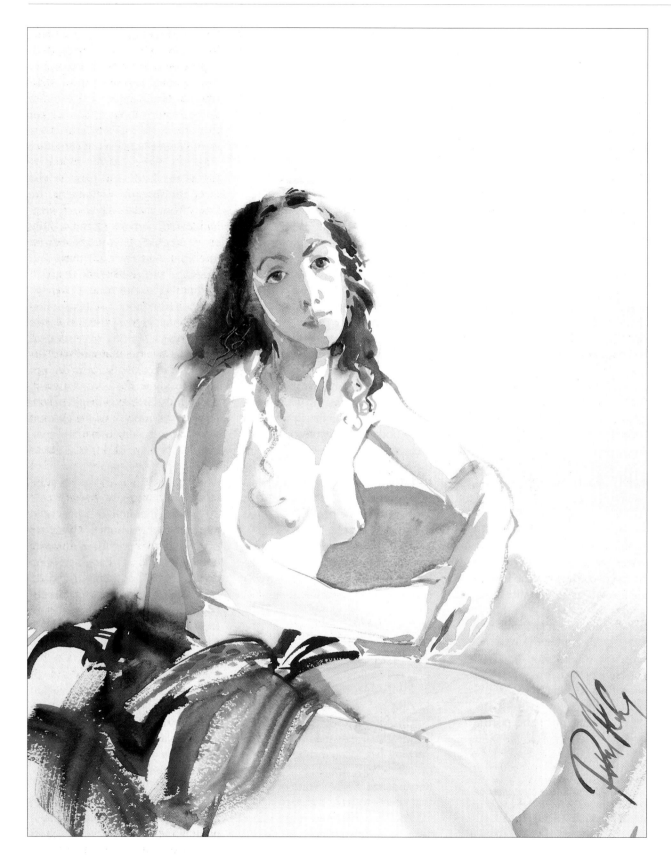

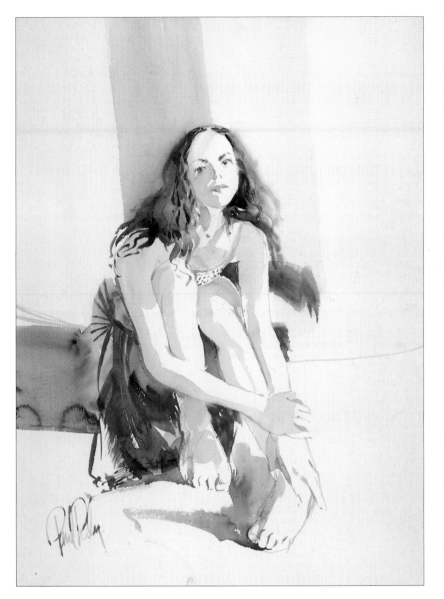

Seated Nude

The arrangement of a figure on the paper is all important. If the head is directly facing the viewer it can be placed in almost the centre of the painting. In this instance the figure is leaning very slightly to the right. I have used the arms to help support her weight and have tried to create a space inside the arms to show the chest. Although this is a life study it crosses over toward portraiture, so I have kept all the other elements relatively simple to help this.

Model resting

I have often noticed that the young have a certain coltish appearance and it is this slight gawkiness that I have tried to bring out in this painting. The conjunction of hands and feet is unusual and sets up a whole series of zigzags leading up towards the face. Note that I have used two very dramatic straight line strokes to lead the viewer's eye in toward this complex image.

reason. Clothing and its attendant folds are also very useful in expressing the form of the figure. The shape of concentric folds around the wrist and arms can show the subtle changes in form that occur in these regions. One note of caution is to ensure that arms and wrists are encircled by the sleeve and that you do not make the mistake of attaching the sleeve to the arm. The same goes for hats. These fit over the head. They are not stuck on as often seen in many paintings and drawings.

A further extension of costume and life is when more than one figure is involved. Eventually this moves into the realm of figure composition which makes its own demands but has many rewards. If your confidence develops through costume life study it is but a short step to making sketches in bars, restaurants or outdoors to observe people in everyday activities.

Undoubtedly the very best preparation for costume life is life painting. The study of the nude figure is probably the hardest task in watercolour painting and the reasons for this are that the subtleties involved in controlling both tones and colour are especially complex. Added to this is the high level of skill required in the basic drawing. I liken life drawing to musicians practising their scales – something they must do even as professionals. The reason why life drawing is so important is that it shows immediately where you have gone wrong. After all, who notices if you have too many branches on a tree, or the wrong number of windows in a tall building? However, it is very apparent when arms are too long, the head too big or you have the wrong number of fingers or toes! So I maintain that to have a good understanding of the figure you must practise, practise, practise! One of the best ways is to join an art group that has life classes or

Stage 1

As with the costume life demonstration I have elected to start with the head. Then, with very careful measurement, I establish the main sections of the figure, namely shoulders, waist, underside of the buttocks, back of the knees, underside of the feet and the positioning of the hands.

Stage 2

Using a soft squirrel brush I like to lay the very first basic wash over the whole figure. Noting as I go the subtle colour changes as I work from the shoulders through the hips and waist and then down to the feet.

Stage 3

In order to obtain secondary tones I dilute my colours even further because any colour placed on top of another will darken the undercolour. I put these on very fluidly and then wait for them to dry before any further merging is done.

Stage 4

Now that all the underpainting has completely dried I can softly merge any hard junction areas. This always must be done very delicately. The underpainting is all in stains of lemon yellow, permanent rose and very pale phthalo blue. This ensures that any merging does not lift the paint, but subtly blends with it.

Susie

All that remain now are the final details. I use a small sable to put in the tight creases. This brush is also used to add weight to the figure by underlining the hands, feet, arms and so on. One of the principle ideas behind this pose is to use the white cloth as a link for the two hands. This was put in with a wide one stroke sable. A small patch of colour to the left of the head gives the model something to look at and at the same time reveals the shoulder.

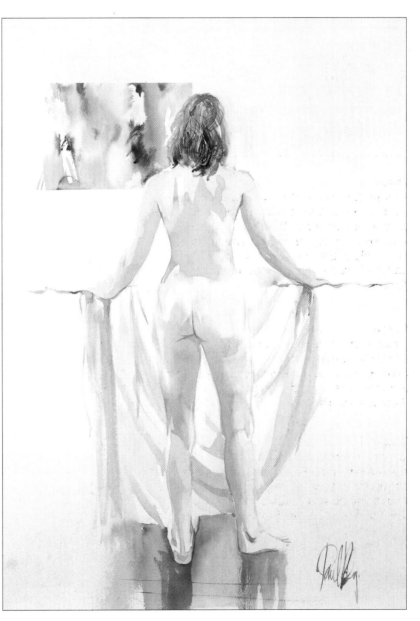

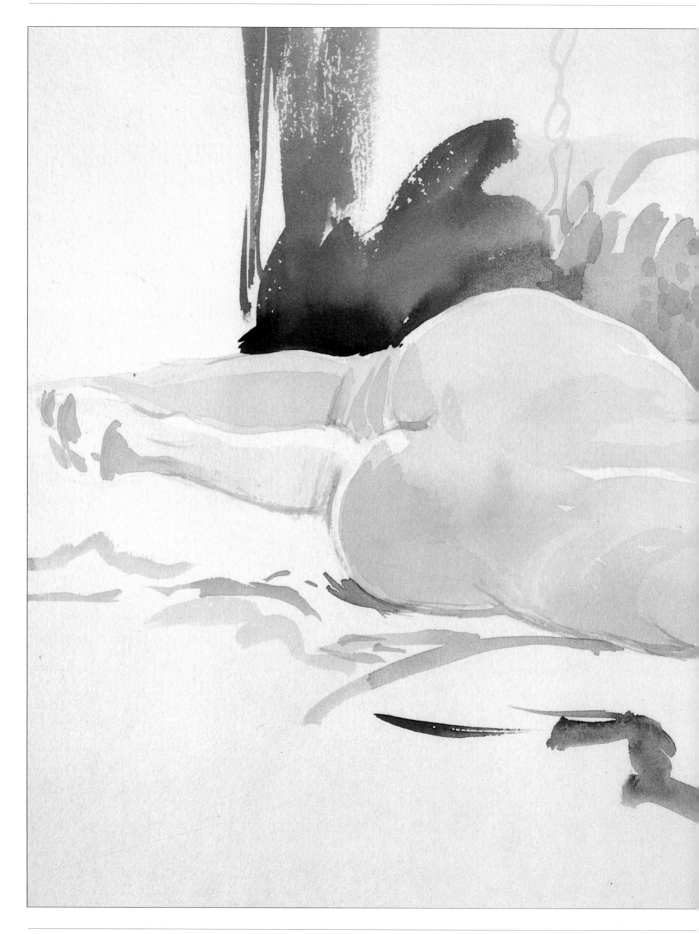

Reclining Nude
In this apparently simple pose there lie one or two significant complexities. The most notable of these is in the foreshortening. This is noticeable in the thighs, feet, back and the upper arm. When painting these areas it is best not to over-emphasise the outline but to work across the form. Considerable background tone has been used to further emphasise the light, delicate skin tones. Because of the horizontal nature of the pose several verticals have been introduced to add tension.

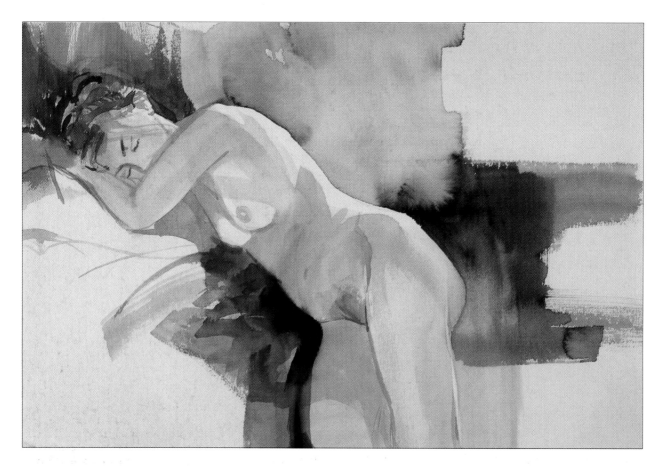

Sleeping Nude

Planning a composition is important and sometimes a preliminary sketch is required. What I produced here was a cruciform style of composition, using background tones across which snaked the lithe figure of the body. I wanted to create a meditative feel and so I have kept my colours reasonably cool.

even just a model. Failing that, form your own small group and hire a model. If that is not possible there is always yourself viewed in the mirror.

The next thing is to train yourself to draw with a brush. I generally recommend a No 2 small round sable – preferably a Kolinsky with a good tip. This enables you to work from the tip to the body and gives you a variation in line thickness. In case you make a mistake have a soft sponge to hand to wipe it out. Use clean water and blot with a soft tissue. Once dry you can continue over the area. For drawing in

colour I use a mixture of lemon yellow and permanent rose diluted so that I can just see it. The reason is that with subsequent washes I can lose the drawing lines to make it appear as if I had not drawn at all.

When setting up for painting it is important to first take careful measurements. This is essential if you intend to include the whole of the figure. I have noticed how many people start with the head then add on the torso and legs only to realise they have run out of paper. They then either truncate the legs to fit the feet in or omit the feet altogether. To measure a standing figure I first put a very faint vertical line on my paper. The top of this corresponds with the top of the head and the bottom with the position of the feet. I then divide the vertical line. One small trick I use is to divide my line into eight then count the number of heads that will fit into my figure. If it comes to seven-and-a-half I

count down and mark it off. This is easier to do than trying to divide a line by seven-and-a-half. It is now easy to establish where the waist occurs or the junction of the thighs and the knees just by counting down the number of heads.

Another small measuring device is a strip of paper that is marked with the size of the head (one eighth the length of your line). I then divide this in half, quarters and thirds. With this device I can now measure the width of sections of the arms, legs, torso and so on by comparing them to the head of the model.

An alternative method is to hold your brush (or pencil) vertically at arm's length. Align the end of the brush with the top of the model's head and slide your thumb down the brush handle until it is sited under the chin. You have now determined the length of the head. Keep your arm outstretched and count how many of

these lengths are in the whole figure, remembering to include the initial head measurement. You will find that if you have done this correctly the total will vary between six-and-three-quarters and seven-and-a-half depending on the model and the viewpoint. I use this method frequently to check my drawing. It is invaluable when analysing poses that have a lot of foreshortening and are thus difficult.

You might perhaps not associate perspective with life drawing but it is relevant. The basic rule of perspective is that the further away something is the smaller it appears and the nearer it is the larger it appears. This is especially notable in a seated pose when the model is facing you. In this situation the head is further from you than the feet. The result is that the feet will be much bigger than you realise. Again, measurements confirm this.

When drawing with a brush I tend not to use a solid line but I keep the line broken to allow light to appear around the form, which

suggests where muscles emerge from behind. This also helps when I lay my first wash. The colour from this wash is similar to the one used in portraits and once again I use stains. The procedure for tonal variations is also the same. To finish I use a dark mixture with mainly phthalo blue and permanent rose to pick out any crisp line work. This is usually in areas of under-shadow and where limbs cross over one another.

A question often asked is what to do about backgrounds. My preferred method is to keep them very simple, the main function of any background colour and tone is twofold. One, to reveal any light tones in the body and enable these areas to be read against the white paper; two, to compliment the flesh colour. Quite often I give the model something to look at, such as flowers or a book. These are then rendered in a very simple way so that they do not to distract from the importance of the figure.

Life painting may seem a little

daunting at first but I have had some spectacular results from students with no formal training who, with a little guidance and a lot of looking, have surprised even themselves.

Languid Nude
In this painting I am aiming for a particular mood. The manner in which the arm lies is very important. It also indicates a dialogue between the hand and the face. To reinforce the mood an overwash of pinks and raw sienna was laid toward the end. The hair was worked in as this wash dried, giving soft edges where required, and the final details were added when the paint was dry.

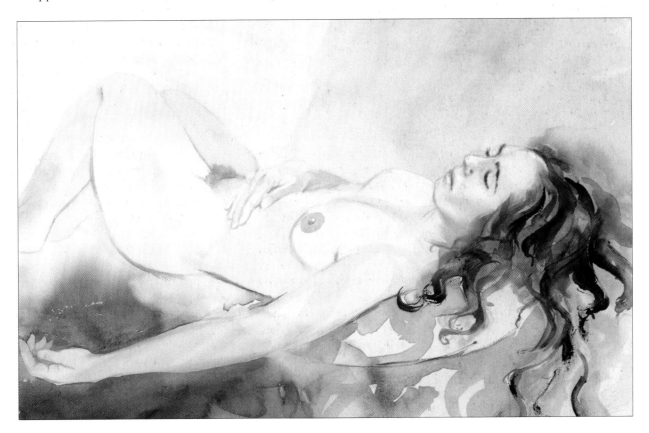

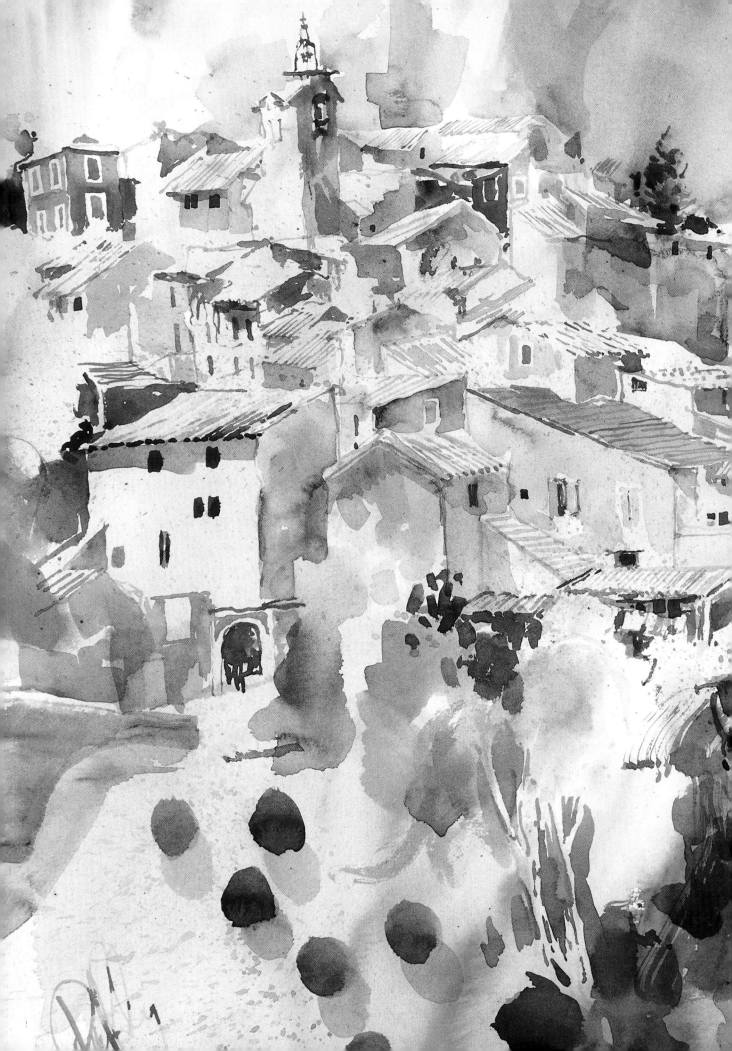

CHAPTER 6

TEXTURE

The structures that we have made for ourselves – to live, work and play – are a reflection of the way we use and try to control our environment. This has produced a plethora of buildings with infinite variety in the components we call doors, windows and so on. This astonishing amount of detail has so much character that, like the lines in a face, it tells stories of times past and the people who lived there. Many painters shy away from painting buildings because of the amount of perspective involved. Yes, it is true that it is there, but with careful choice of viewpoint it is possible to limit these complexities. We are now going to look at the many textural variations to be found in buildings and their interiors.

Stage 1

First I lay an underwash of raw sienna, mauve and permanent rose. The wash is applied to wet paper but sparkles of white paper are left. Be bold with underwash colours because they set off the picture with a vigorous statement, and if you want to reduce to grey or brown tertiaries you will have a positive colour as a basis.

Stage 2

I put the colours for the flowers down onto white paper as soon as possible and keep them light – mainly permanent rose with a little cadmium red. Noting their relationship to the doorway and the street, I lightly indicate the elderly couple using a fine Oriental wolf hair brush. Place figures early in a composition so they do not look 'stuck on'.

Stage 3

To add textures to the buildings I apply masking fluid with pen and folded card. When dry this is washed over with strong dark tones using a sable one stroke. Note my perspective device. I am using a piece of string and a paperclip with one leg folded up and taped to the paper. The clip is positioned over the vanishing point.

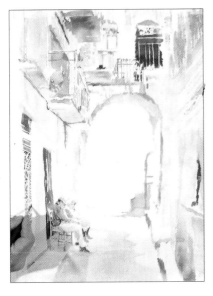

Stage 4
Now comes the detail stage which involves extensive negative painting. For example, I am showing the yellow iron trelliswork by painting the dark tones behind it. Further details are added to the two figures. These details are added with a good quality number three round sable. Light, deft touches keep the spontaneity of the work.

Greek Street Scene
I have been looking forward to the final stage, which is the sun-drenched wall in the background. It is most important to keep the detail restrained in this area. This will then allow this section to recede but to still maintain interest. I use a varied mixture of raw and burnt sienna and with dry side-action of the one stroke sable brush add both texture and line work.

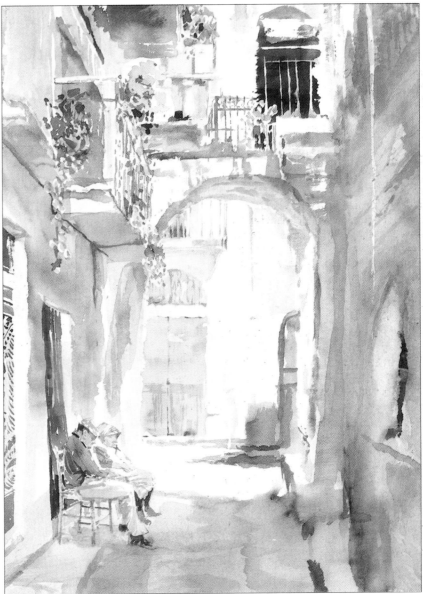

dried masking fluid I have found that the best way is to allow some fluid to dry in a small shallow dish. When dry, roll it up into a ball and use it as an eraser. Be sure to let the overpainting dry thoroughly otherwise you will get into an unholy mess.

Windows are just one of many elements which are particularly significant in buildings. They are the 'eyes' of the building and give expression to the façade and, like eyes, show the greatest tonal contrast. Try to avoid any woolliness in either tone or drawing when depicting the windows. They should by sharp and crisp in detail. Remember that glass is both reflective and transparent therefore both of these qualities need to be shown. One strange phenomena, as reflected in the glass of a window, is a reverse shadow, which is cast by the lintel and jamb. This reverse shadow is lighter than the rest of the window. Other reflections are invariably of objects such as buildings, trees or sky that are behind you. You should also note that small details like curtains, or even window openings, can often be seen on the far side of the room behind the window you are painting. One of the failings of many buildingscapes is the way in which they are depicted at ground level. Unless they are uncompromisingly built on to a concrete slab you will rarely find that they terminate in a straight line. Try and suggest their growth from the surrounding terrain. The use of foliage is one way that we attempt to soften a building's severity of line. This, together with other objects, or even people, can be used to lead the viewer's eye towards your interest in the building. Not only do you need to consider aspects in the foreground but also what goes on behind the building. It is important that these elements really do appear to come from behind, with no gaps showing which would

Ananda Cottage, Bali
Bali is a hot, lush, tropical country. This produces an endless variety of foliated textures. The different leaf forms required different brush sizes and shapes. Additional texture was added by dropping paint and splattering in. With a penknife I scraped back some of the dark areas to the white paper. Dry brushwork was used to produce the thatching on the roof. Palm trees can be laborious to paint, as you often have to do extensive negative painting to create depth. A flat, one stroke sable helps considerably.

imply that they are floating over the rooftops. You can give a sense of depth to these areas by painting the trees, for example, slightly softer and with more blue in them. You can achieve this softening effect by lightly wiping the trees with a sponge after the paint has dried.

One of my favourite settings for buildings is whenever they are surrounded by water. This gives the painter the opportunity to look at and paint reflections. Just remember that reflections show the building vertically below it so that all windows, doors and so on will be seen vertically below one another. Sometimes it is easier to turn the paper and paint this zone upside down so that it looks the right way up!

With regards to perspective I shall not go into detail as it is beyond the remit of this book. There are many good publications, including my own landscape book, which cover this subject well. I will, however, give a couple of tips that can make your life easier. As I mentioned earlier, if you sit square on to a building the majority of perspective is then eliminated. However, there will be a little of what is called one-point perspective. This is where all wall, door and window reveals are seen at an angle that radiates from a single point. Determining this point is simplicity itself. Whether you are seated or standing, look straight in front of you, place your pencil pointing outwards from between your eyes and note where the pencil point occurs. It may be by a window or half way down a door but the fact is that, provided you have kept your head level, you will have established your eye level and position in relation to the building. If you mark this dot on your drawing you will be able to radiate all of your angles of perspective from it.

Another device that I use is a simple card frame which has a sliding horizontal bar incorporated

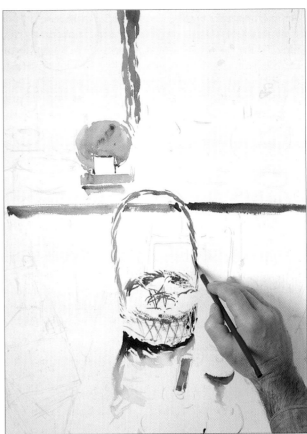

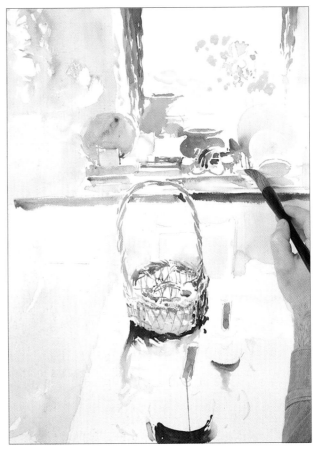

Stage 1
This interior is a relatively simple one for
beginners to attempt. First, I am seated directly
in front of the wall opposite and 'square on'.
Using pale blue, I begin by lightly drawing-in
the main structure of the composition.

Stage 2
The table is also set square to the wall but before
indicating this I commence with painting the
objects on the table. Note that I have started from
the very top of the painting right through to the
bottom. This is in order to keep the painting
moving and I do not dwell on any particular area
for too long.

Stage 3
Background details are now added. The variety
of objects is seen as simple shapes against the
light. This is frequently referred to as *Contre-
jour* painting.

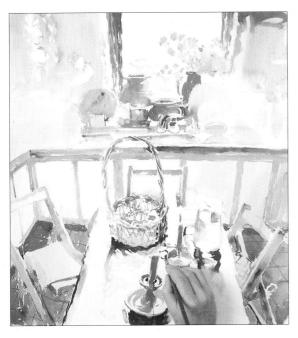

Stage 4
The bulk of the objects has been completed and now is the time to introduce the surrounding area. Again these sections are kept very simple.

The Kitchen
To complete the painting, all the final background and foreground areas are filled in. Extra colour provided on the left helps to show the shapes of the chair backs. The principle idea behind this painting is a series of rectangles. The only perspective involved is the sides of the table and the left counter top. A beginner wishing to tackle interiors should try this view and so avoid too much perspective.

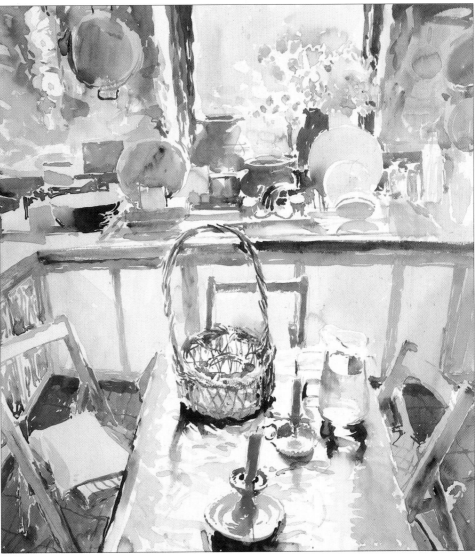

where figures can play a significant part, add fascinating opportunities for the painter. Most of these locations do not enable you to set up your easel and paints. However, a sketchbook and camera may well provide enough information to help you work up a painting at home. Try not to simply copy a photograph. Use your sketches for basic ideas and for designing a

St Nicholas, Prague
Probably the most complex interior you are ever likely to see. It therefore called for a very expressive means to achieve it. I first painted all the suggestions of Rococo movement with pure masking fluid. When this had dried I overwashed it with delicate pink and green tones. A further application of masking fluid produced the rich and convoluted decorations. Very, very dark tones were then added to create depth.

composition, then rely on your photographs for technical details like window fenestration and particular textures. (This is how the painting on page 116 was created.)

Whenever you encounter an interesting, gritty building or one with a dilapidated atmosphere, like a ruin or a workshop, it gives you the opportunity to use precipitating or granulating pigments for added texture. These are pigments such as the earth colours raw and burnt umber. Ultramarine will give a similar effect when used in the shadow areas of these subjects.

It is easy to get bogged down in detail when painting interiors and to be tempted to use a ruler for the straight lines. You can approach it much more freely than you would imagine, so give it a try if you have not already been inspired.

Lunchtime
A kitchen view offers many opportunities for painting texture because of the sheer number of objects available. To create depth I have used various textures to frame the view of the diners, from the tiles in the background to the baskets, woodwork and stonework. All these areas need to be seen simply otherwise chaos would result.

CHAPTER 7

IMAGINATION

I do not think it is true to say that some of us have imagination and some of us simply do not. Fear is one emotion that everybody has since it is one of our defence mechanisms. It is fear, for example, that is often a result of our imagination. One way in which we may stimulate our imagination is to picture ourselves in another world – one of our own making. You could say that this is daydreaming, and in my case it certainly is. The disciplines of painting and drawing can be brought together to explain what is happening in our mind's eye as it were. I will show you the various devices I use to kick-start my mind to add that illusive *'Je ne sais quoi'* – that special quality which intrigues the mind of the viewer.

ACKNOWLEDGEMENTS

After writing a book the feeling is akin to that of having run a marathon. As with runners, it is not just a solo event and is very much a team effort. I am most grateful to the support crew who suffered in so many ways. The maddest of the team is undoubtedly my publisher, David Porteous, who believes in me sufficiently to publish this, my third book. My English teacher considered me dyslexic – although that word had not been invented then and his descriptions were rather more ripe. So, I need a fine filter of typists, spellcheckers and 'punctuationists' – my deep-felt thanks to Mark and Sarah.

Behind every artist should be a great wife. I am lucky that Tina has got me out of bed, kicked me through the day and helped me to complete on time. She has also been brilliant at interpreting my occasional gobbledegook!

Special thanks to Mimi and Margaret for home comforts, and to Sally Bulgin for keeping faith and giving me time off.

I much admire creative skill and the quality of this book is due to Garth for his photography and to Malcolm for his design.

Finally my respect and love to my numerous students, who over the years have been my test-bed for ideas and who have also given me such joy in pursuing this fascinating art, painting.

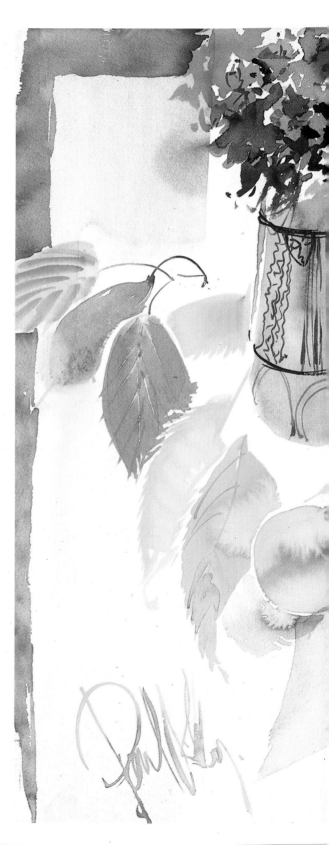

Autumn Leaves with Candle

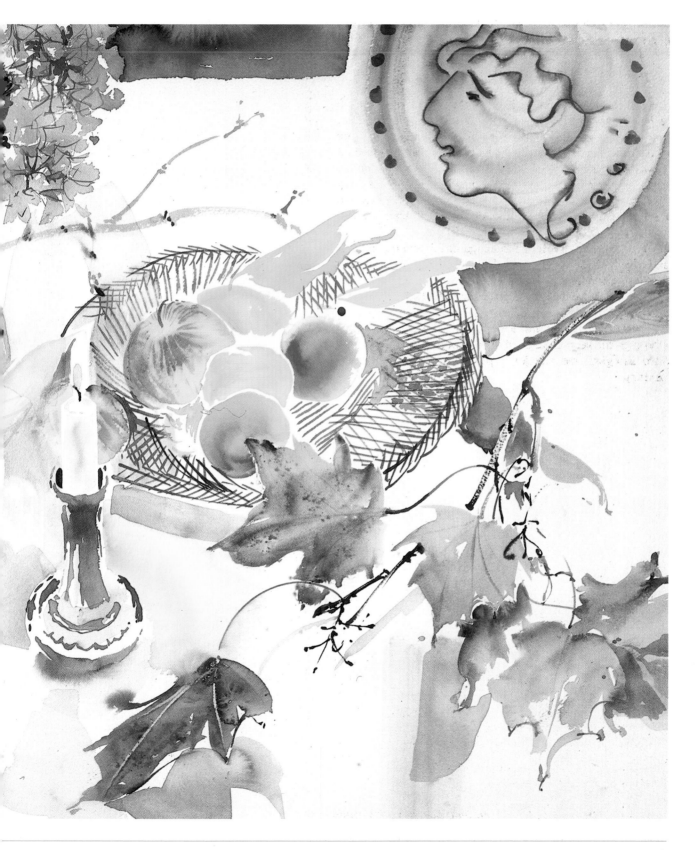

GLOSSARY

Body colour
Pigments that have been rendered opaque by the addition of chalk white, for example gouache.

Complementary colours
Colours which harmonise and are opposite on the colour wheel, for example red, green and blue are complementary to orange, yellow and violet respectively.

Conté
A form of hard pastel in stick or pencil form.

Contre-jour
Against the light.

Crosshatching
Tonal variation produced by using parallel lines of monochrome or colour. The lines are generally laid at an approximate 45% angle then overlaid with further lines at a steeper angle to give a darker tone.

Eye level
One's height in relation to a view looking straight ahead. High eye level implies looking down and low eye level looking up.

Ferrule
A sleeve, usually metal, enclosing the bristles of a brush and attaching them to a wooden handle.

Form
Solid form is expressed in painting by using tonal variations of colour.

Format
The shape of a painting – vertical, horizontal, square and so on.

Gum arabic
A resin from various trees which is soluble in water and is used to bind pigments to the paper.

Hue
A colour or tint which is either a primary colour or a mixture of colours.

Local colour
The true nature of an object, for example green leaves or blue sky, which is unaffected by reflected light, atmosphere, or the mind of the artist.

Medium
The liquid constituent of a paint in which the pigment is suspended in oil or gum arabic and water.

Monochrome
Single coloured.

Palette
A surface or container used by painters for mixing colours.

Pigment
The basic colour constituent in paint before the addition of a medium such as oil, gum arabic and water.

Plein air
Painting out of doors as opposed to in the studio.

Pointillism
A system of applying colour in the form of dots which optically mix when seen from a distance.

Polychromatic
Many coloured.

Primary colours
Basic red, yellow and blue are primaries. Secondary colours are a mixture of two primaries, say yellow and blue to make green. Tertiary colours are a mixture of all three primaries and generally produce browns.

Resist painting
Using substances like rubber or wax, which are insoluble in water, to resist wet watercolour. Used for highlights and negative painting.

Splattering
Using a toothbrush or stiff hog hair brush dipped in colour and then drawing the fingertip across the bristles to flick random dots of colour on the picture surface. Areas may be masked off using cut out newspaper.

Sponging
Using a soft natural sponge for lifting and softening paint areas.

Tachisme
The art of dropping, splattering and pouring paint onto a surface.

Tone
Gradations from light to dark in a painting.

Viewpoint
One's relationship to a view looking straight ahead.

Wash
A layer of evenly distributed watercolour laid in a series of horizontal overlapping strokes. *Underwash* – either a flat monochromatic or multi-coloured graded wash laid before painting commences. *Overwash* – layers of thin paint laid over finished painted areas.

Wet-into-wet
A technique of watercolour painting which involves putting wet paint onto damp or wet colour in order that the two blend.

Wove
A type of paper finish, so named because of the method of manufacture. The screen from which the paper is couched is a woven mesh.

INDEX

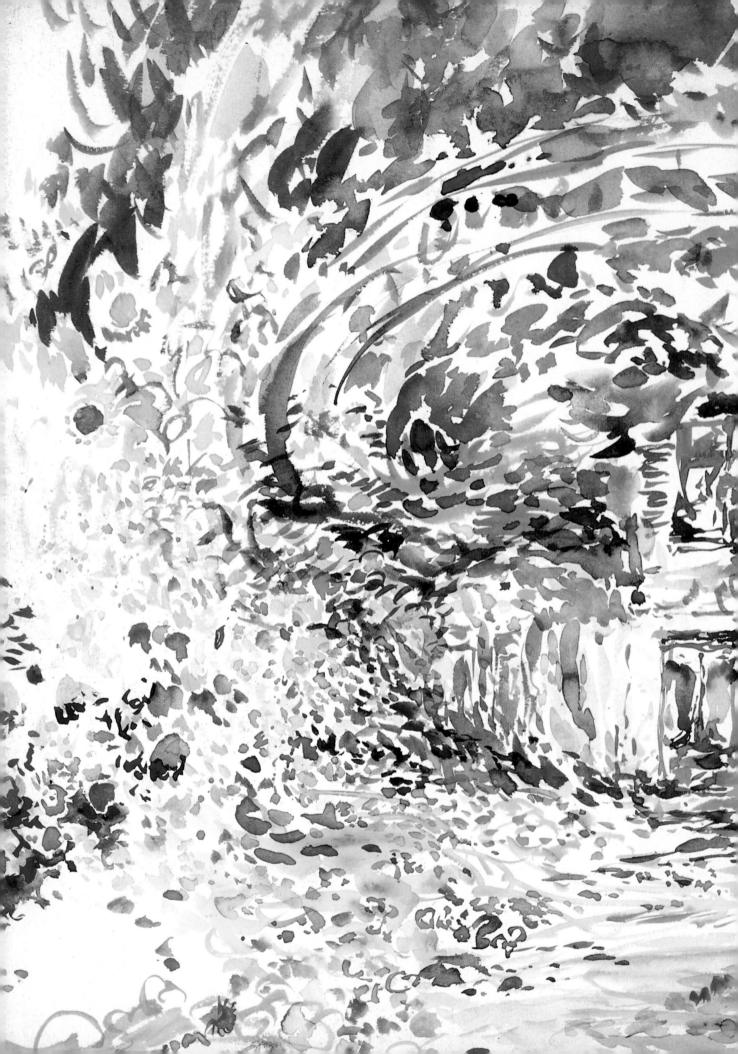

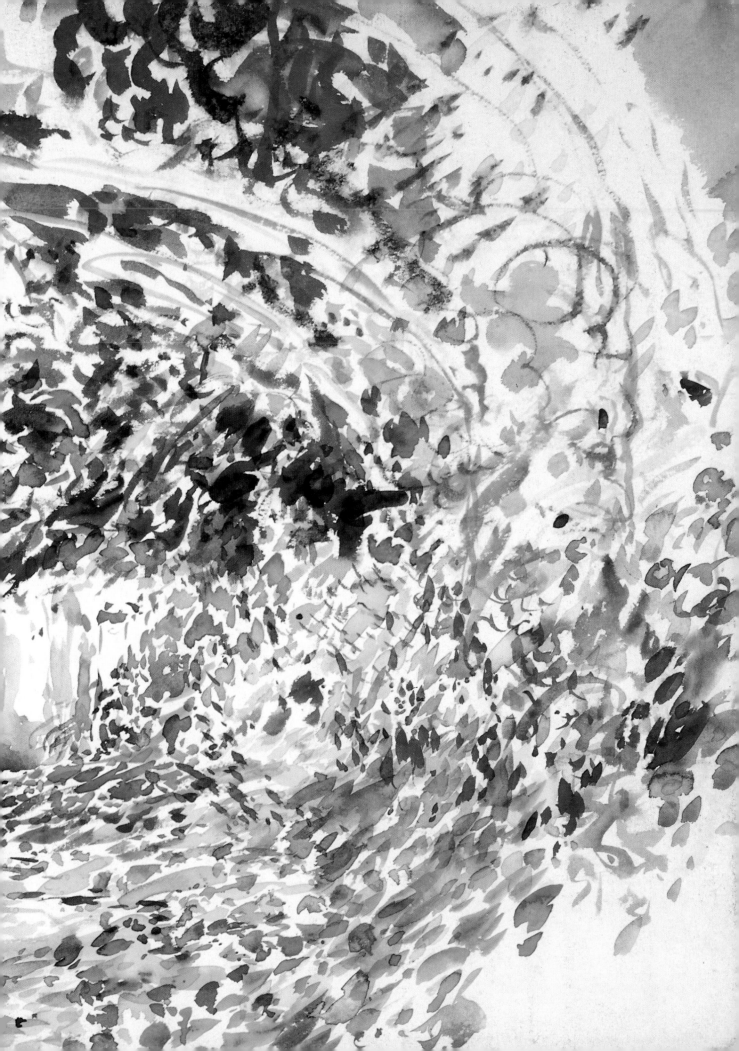